TATTOO SOUP

A COMPENDIUM OF THE GLOBE'S MOST UNIQUE TATTOOS

Ⓘ

Independent Music Press

P.O. Box 69, Church Stretton, Shropshire SY6 6WZ Fax: 01694 720049

Visit us on the web at: www.impbooks.com and www.myspace.com/tattoosoup

TATTOO SOUP is a book of photographs of tattoos. It's a collaboration between the publishers – Independent Music Press – and the fine folks that submitted their own tattoos to the pages of this book.

So it's a book of tattoos.

But it's not a book detailing the historic elements of tattooing or in-depth facts.

It's just a book of tattoos.

Tattoos that are on show.

Tattoos that are proudly worn by these folks everyday.

Tattoos that are proudly shown by the tattoo artists that make them.

Some folks cannot understand the passion and dedication it takes to wear a tattoo.

But once you have one done, it becomes more evident.

Tattoos are something that are earned by the person who wears them, through the time and endurance it takes to get one done. Tattoos are also an expression of art by the people who make them – they are placing their work on someone else, to show.

And to wear forever ...

Tattooing has been around for thousands of years, from the cavemen to the Egyptians and so on. Plenty has already been written about this lineage. But here in this book, through these photos, we can see the extent of the evolution and realise what tattooing is today. How the bar has been raised in just the past fifteen years alone is incredible.

Although tattooing has grown in popularity over the years, we are still part of a subculture. That subculture itself is influenced heavily by many other subcultures. For me, it was the punk/skin

scene in the 1980s; for some, it may come from biker style; others are inspired by old style military tattoos that they saw on their grandfather's or father's arms; or the love of Japanese art ... etc.

But all these elements give us one passion in common ... tattoos.

No matter what background, country or culture.

And that, more than anything, is what **TATTOO SOUP** represents – a cornucopia of many styles of tattooing from all over the globe.

I hope you enjoy and appreciate this project. I myself am very proud to be a part of the book you hold in your hands and I've had fun helping anyway I could with it. Tattooing has done so much for me and this is one way of giving something back. When I was asked to participate I didn't think twice about it; seeing the other books the guys from Independent Music Press have published before, I am sure they will do a great job to represent us – the tattooed and the tattoo artists.

I am sure that **TATTOO SOUP** will be recognised as an important book that we will all look through over and over again. For years to come ...

All the best,

Phil Kyle

· MAGNUM OPUS ·

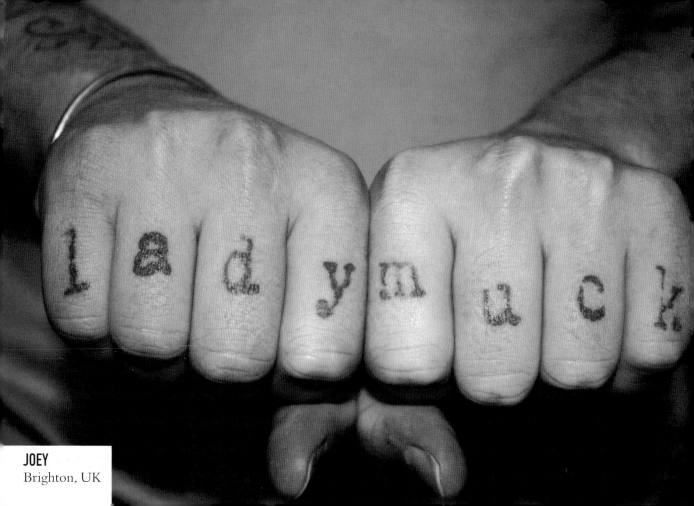

JOEY
Brighton, UK

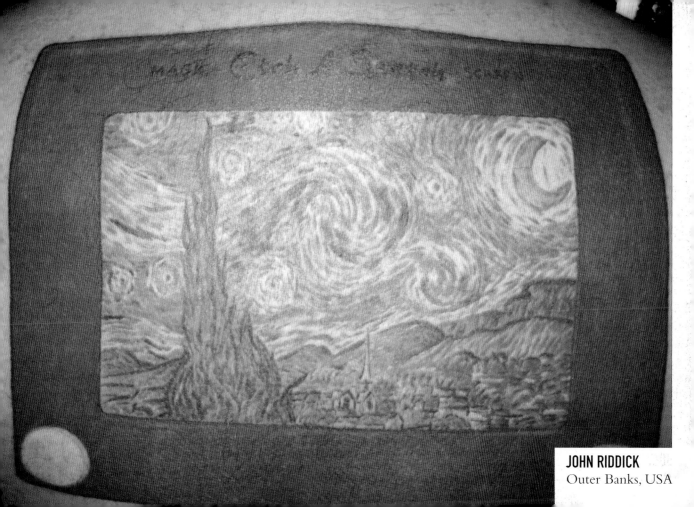

JOHN RIDDICK
Outer Banks, USA

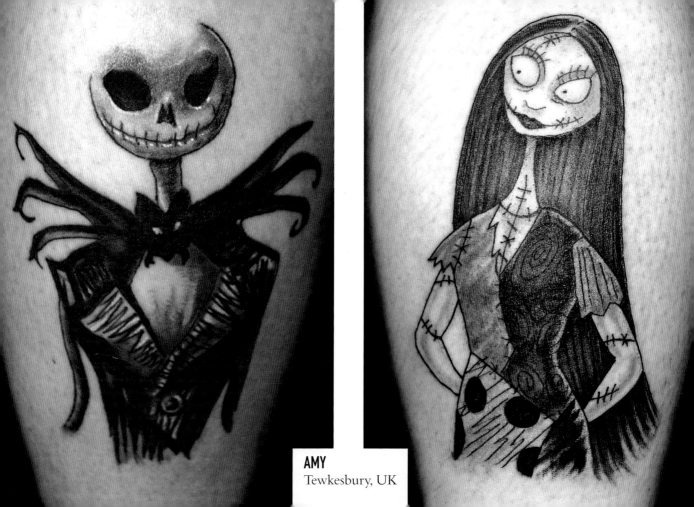

AMY
Tewkesbury, UK

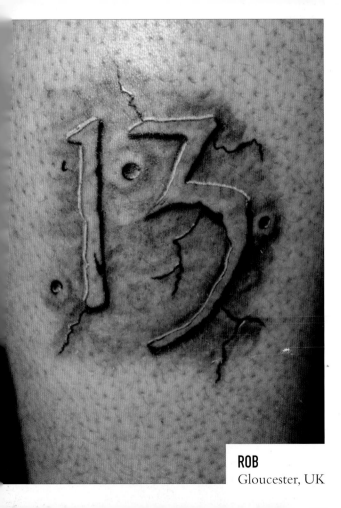

ROB
Gloucester, UK

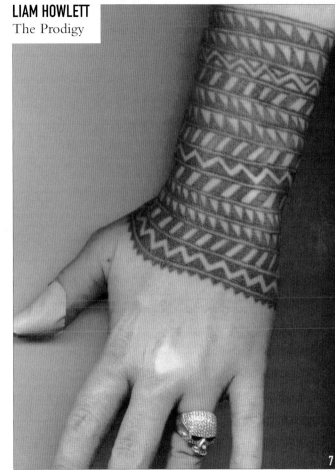

LIAM HOWLETT
The Prodigy

7

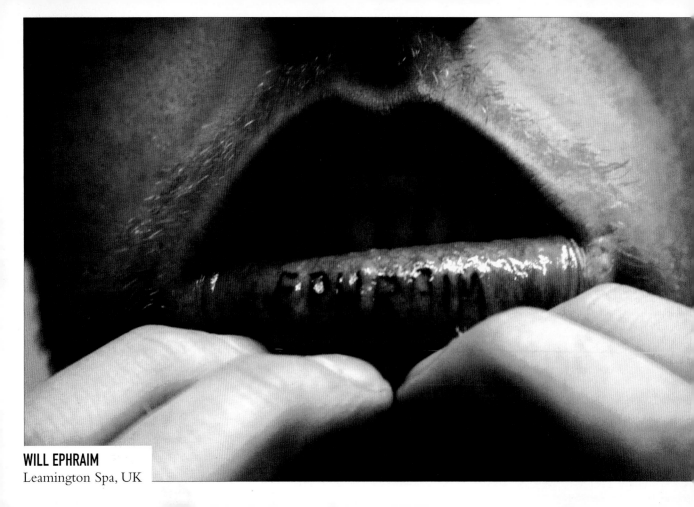

WILL EPHRAIM
Leamington Spa, UK

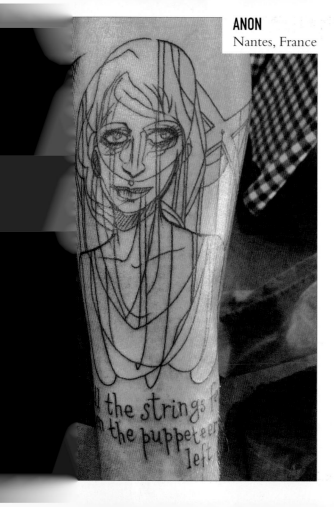

ANON
Nantes, France

the strings from
the puppeteer
left

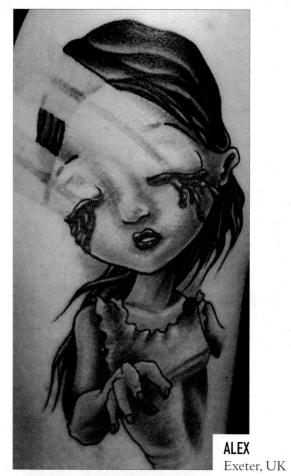

ALEX
Exeter, UK

9

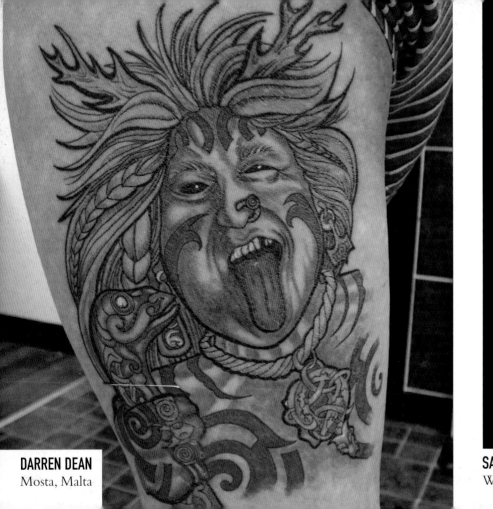

DARREN DEAN
Mosta, Malta

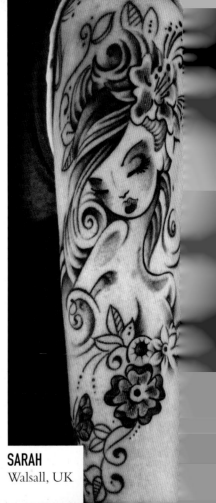

SARAH
Walsall, UK

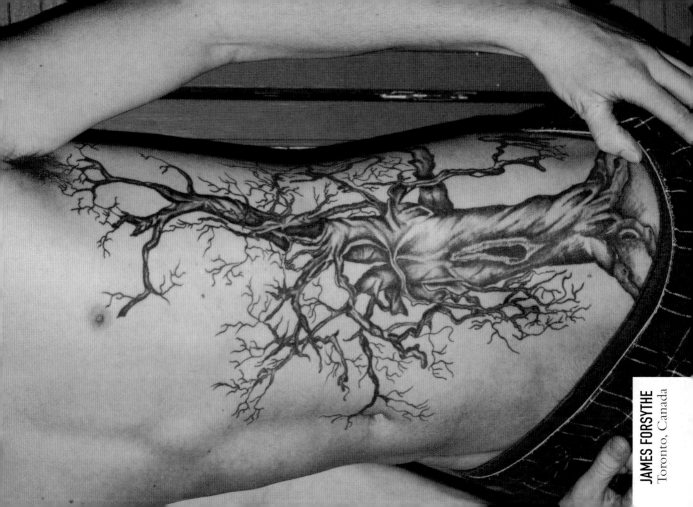

JAMES FORSYTHE
Toronto, Canada

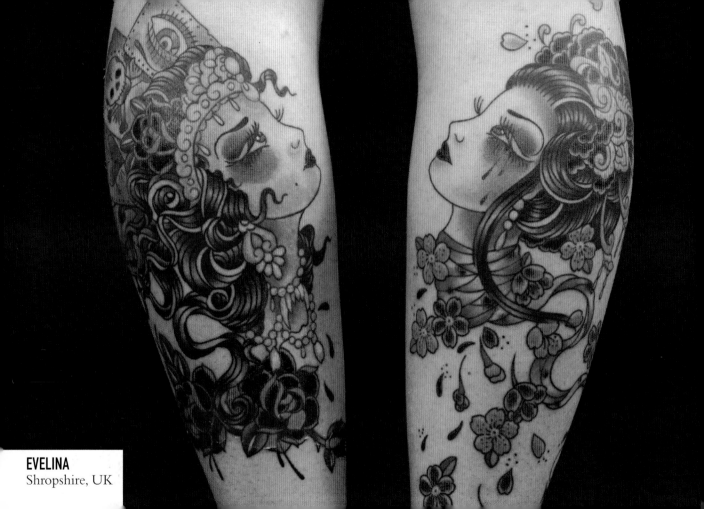

EVELINA
Shropshire, UK

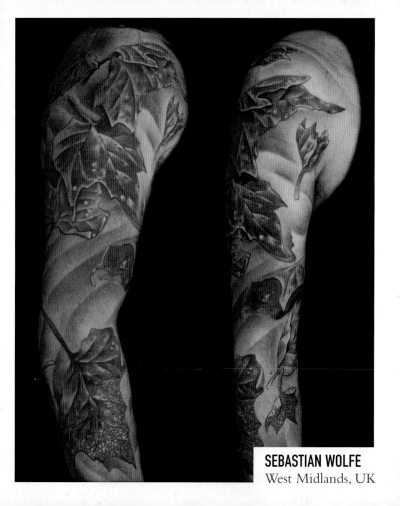

SEBASTIAN WOLFE
West Midlands, UK

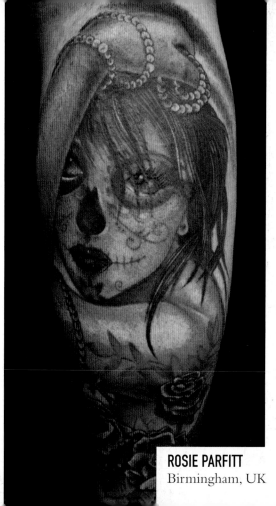

ROSIE PARFITT
Birmingham, UK

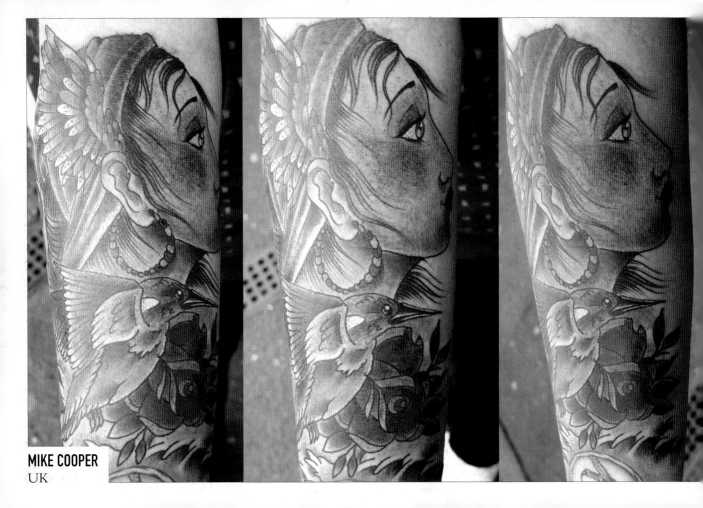

MIKE COOPER
UK

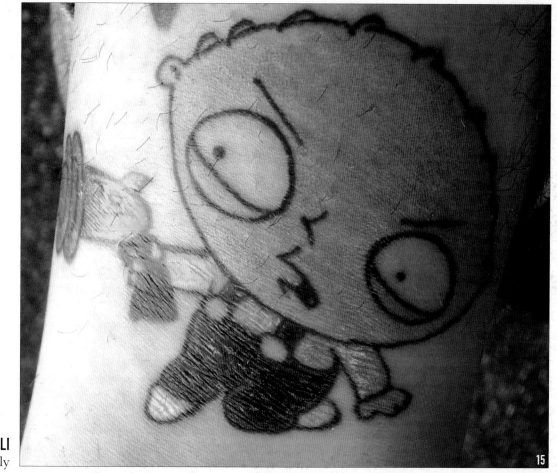

CRISTIAN DONELLI
Reggio Emilia, Italy

15

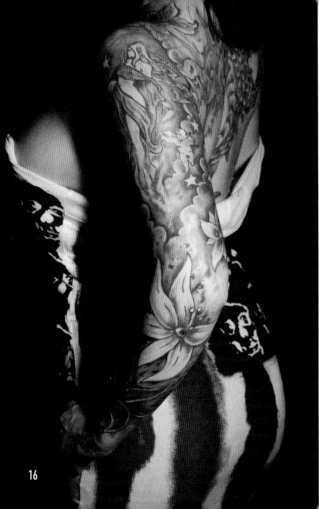

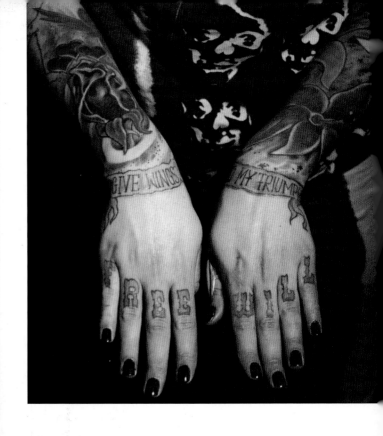

AGNIESZKA GOGOLEWSKA
Northamptonshire, UK

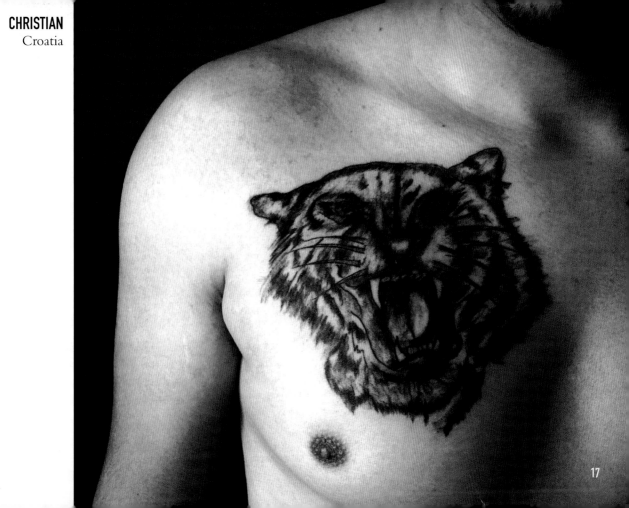

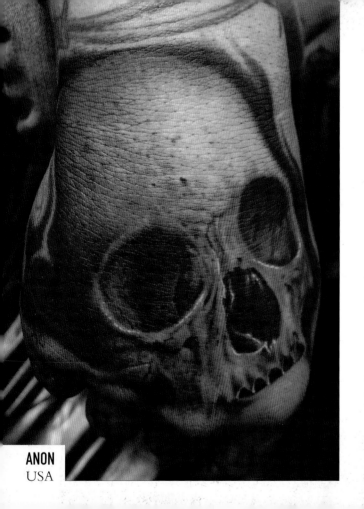

ANON
USA

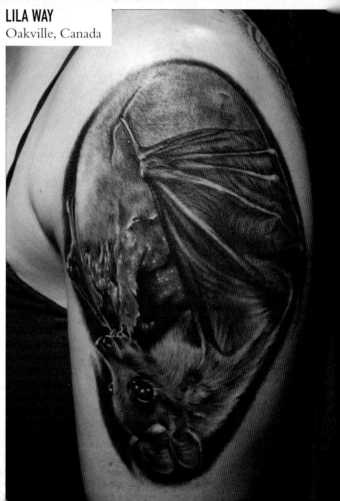

LILA WAY
Oakville, Canada

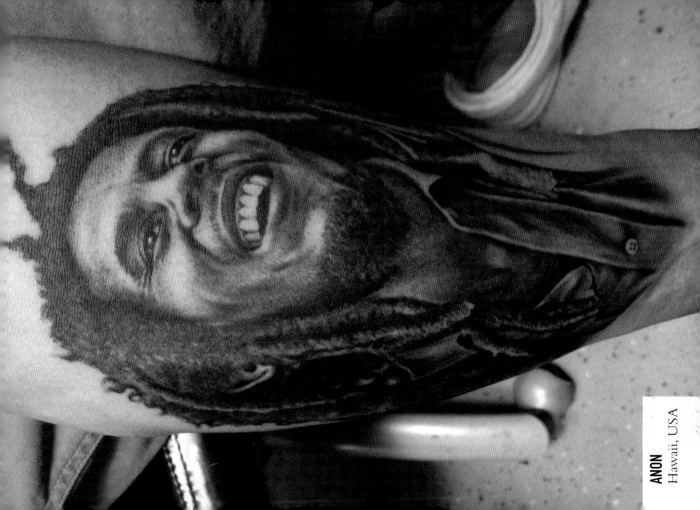

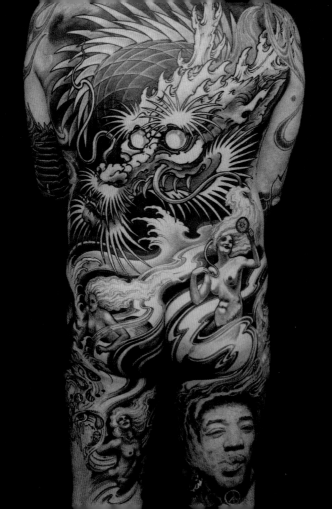

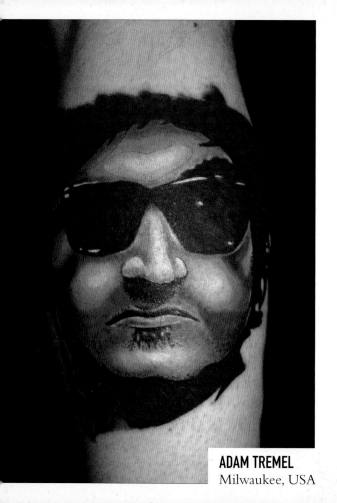

ADAM TREMEL
Milwaukee, USA

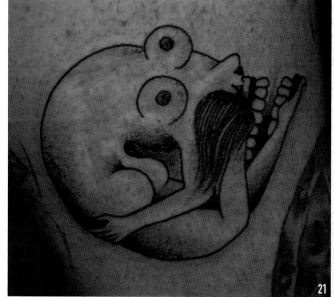

21

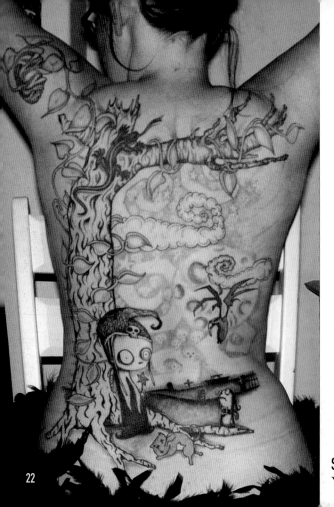

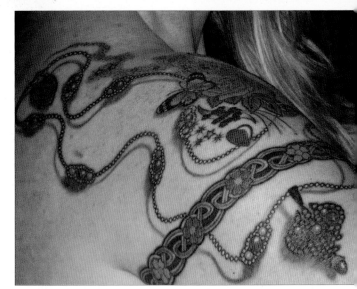

MELANIE AKA SOULKISS
Merseyside, UK

SUZI
Yorkshire, UK

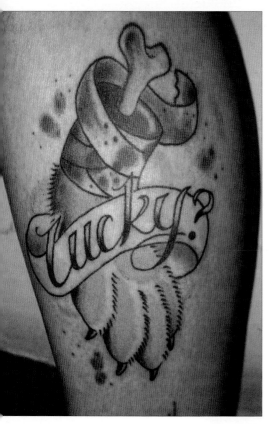

ZOE MILLS
Lincoln, UK

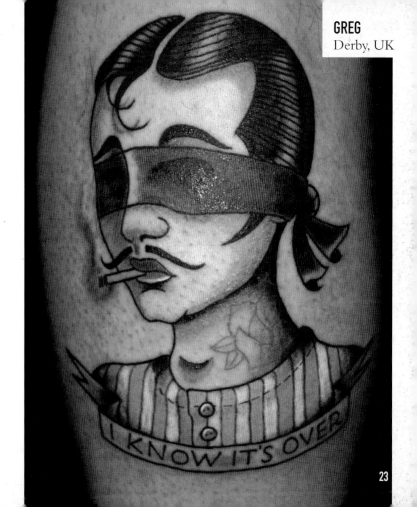

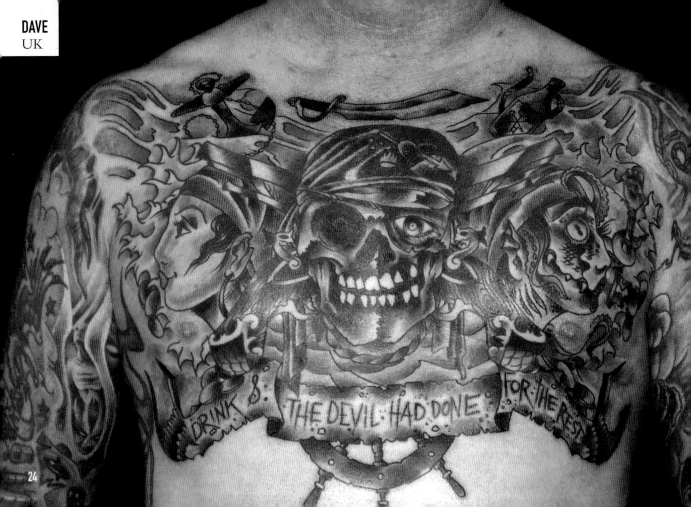

DRINK 8. THE DEVIL HAD DONE FOR THE REST

24

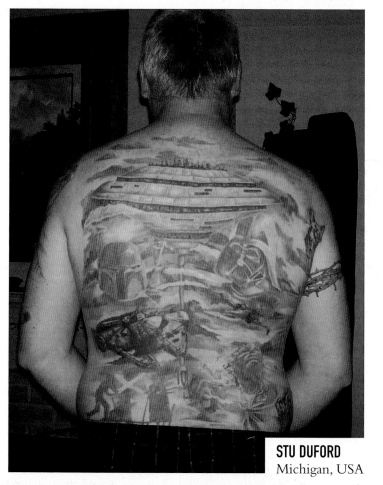

STU DUFORD
Michigan, USA

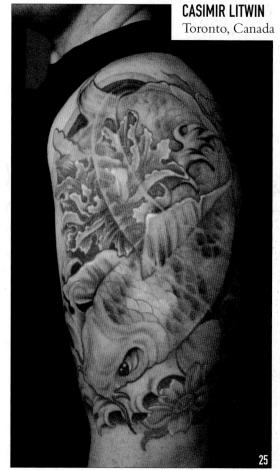

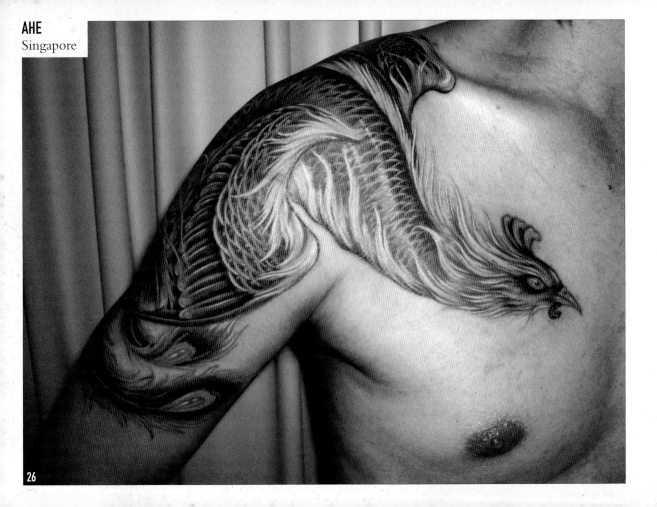

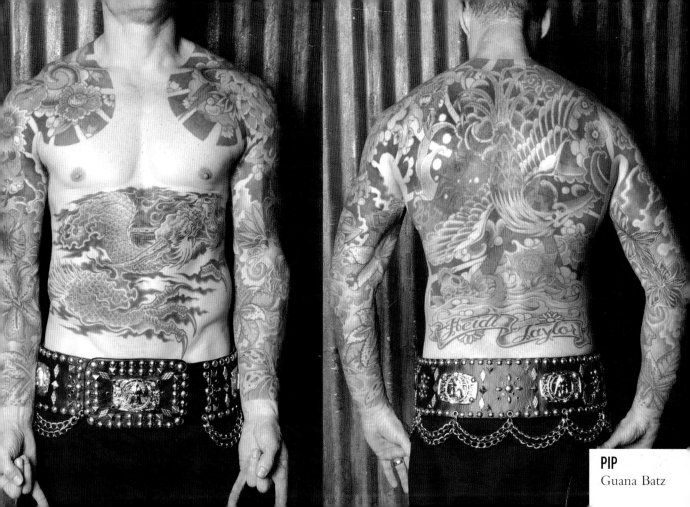

PIP
Guana Batz

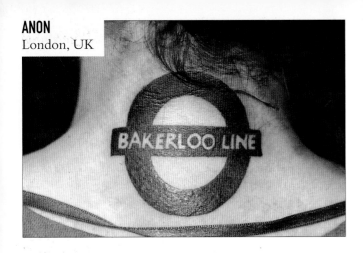

ANON
London, UK

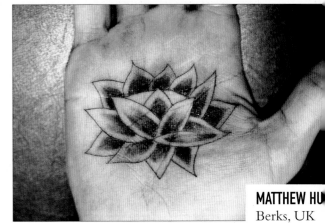

MATTHEW HU
Berks, UK

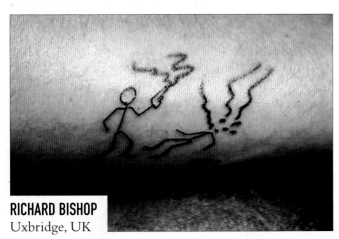

RICHARD BISHOP
Uxbridge, UK

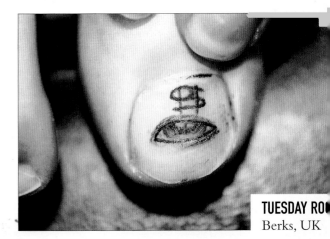

TUESDAY RO
Berks, UK

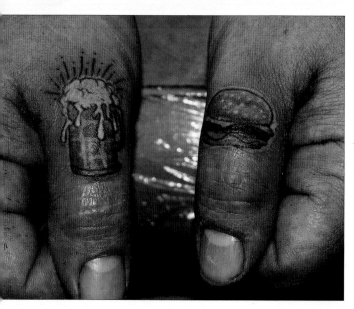

CHRIS HARRIS
Brixham, UK

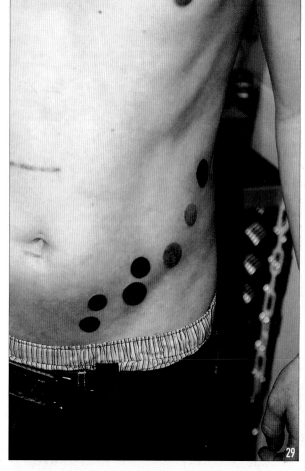

MIKE
Uxbridge, UK

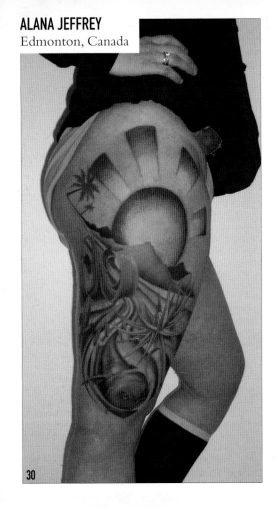

ALANA JEFFREY
Edmonton, Canada

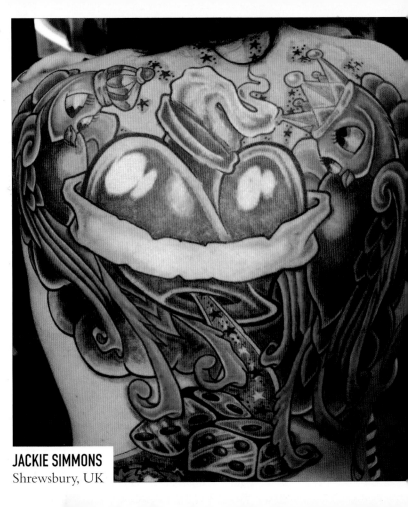

JACKIE SIMMONS
Shrewsbury, UK

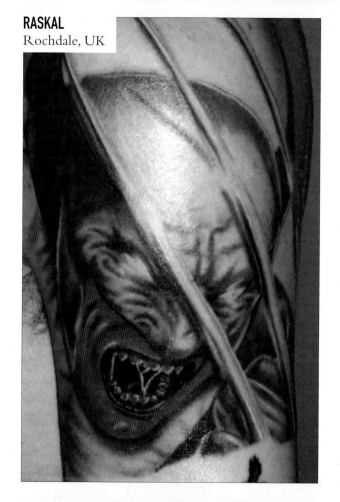

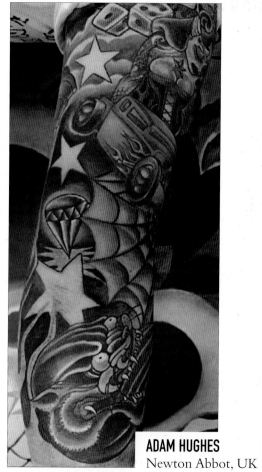

ADAM HUGHES
Newton Abbot, UK

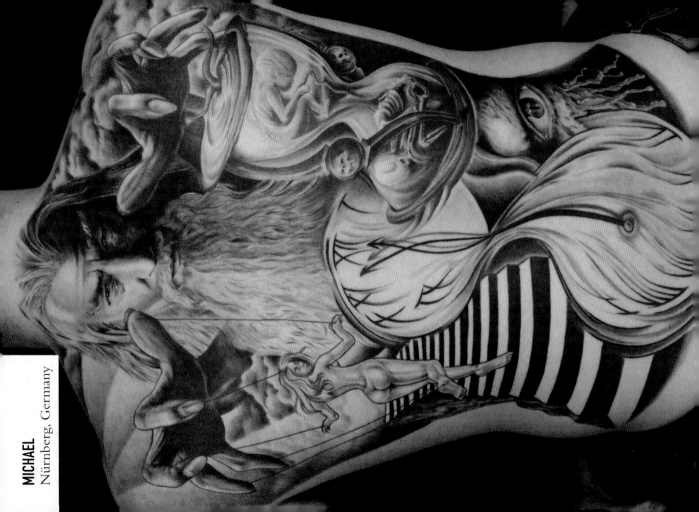

KATRIONA GODWARD
Helensburgh, Scotland

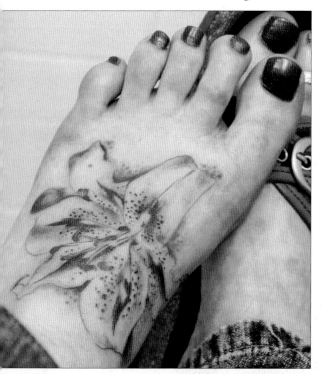

DAN WALTERS
Cardiff, Wales

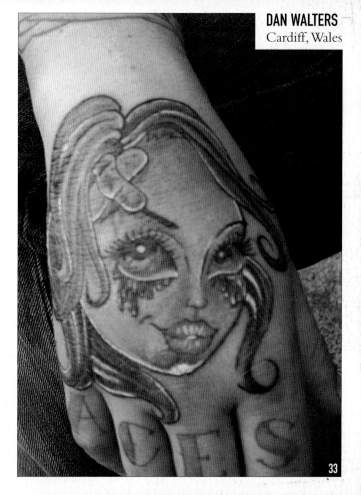

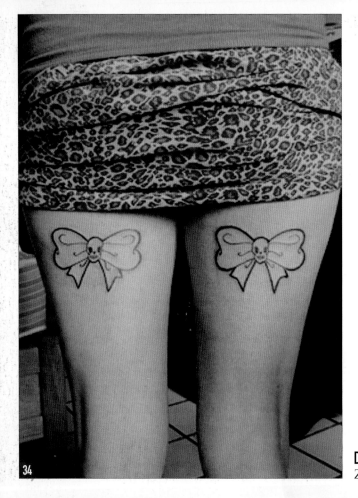

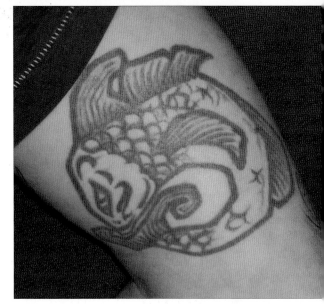

JAMES PINNER
Telford, UK

DIANA
Zamora, Mexico

ANTHONY PARKER
Llysfaen, Wales

DR NICKY
Blackburn, UK

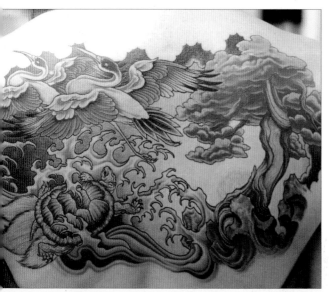

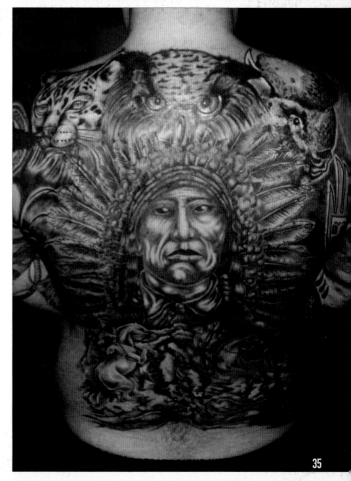

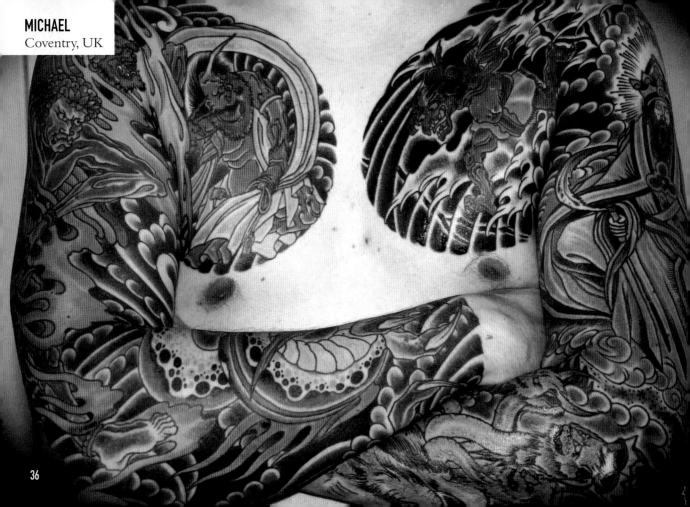

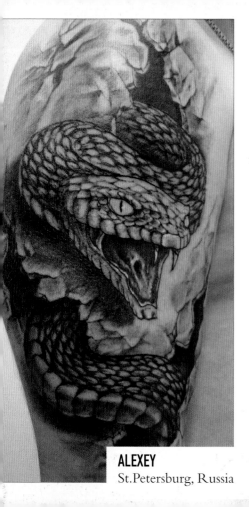

ALEXEY
St.Petersburg, Russia

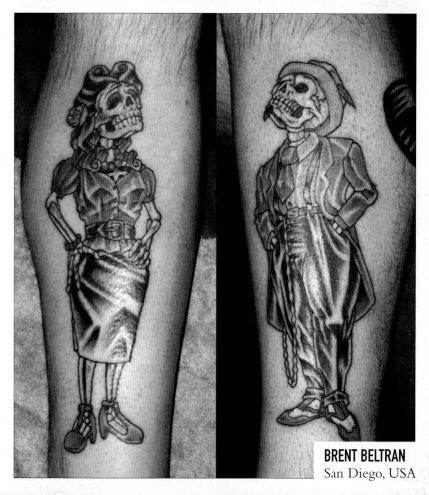

BRENT BELTRAN
San Diego, USA

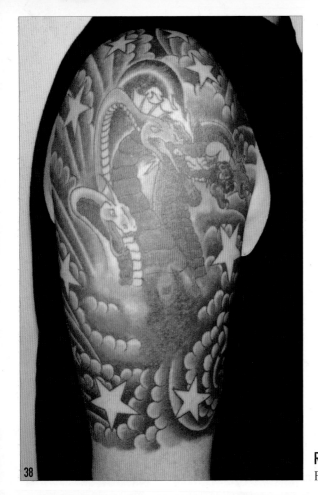

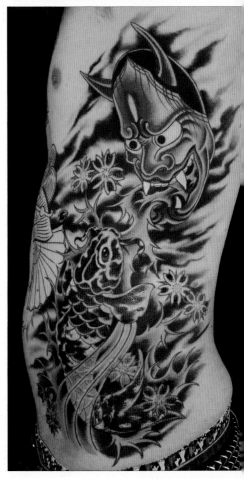

RYAN RICHARDS
Funeral For A Friend

38

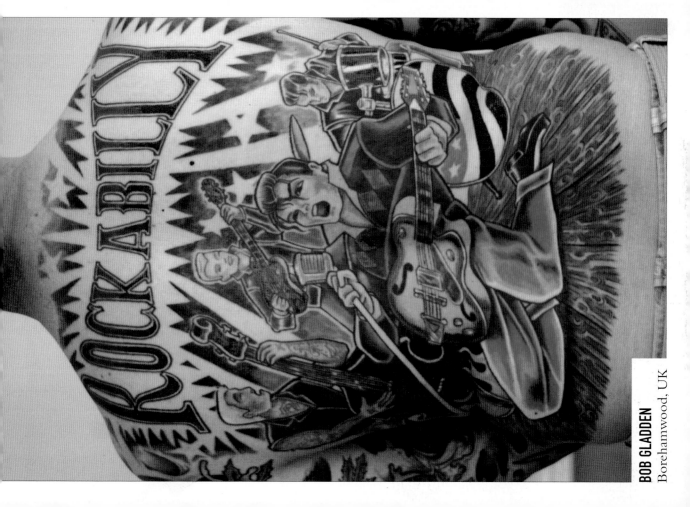

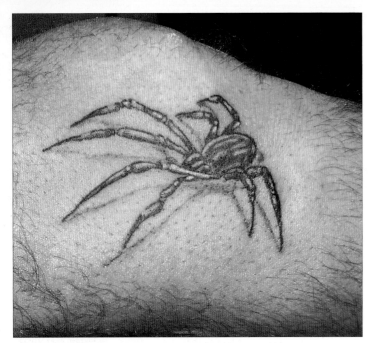

DAVID SAURON
Limoges, France

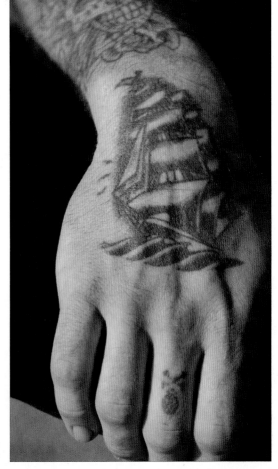

NATHEN MAXWELL
Flogging Molly

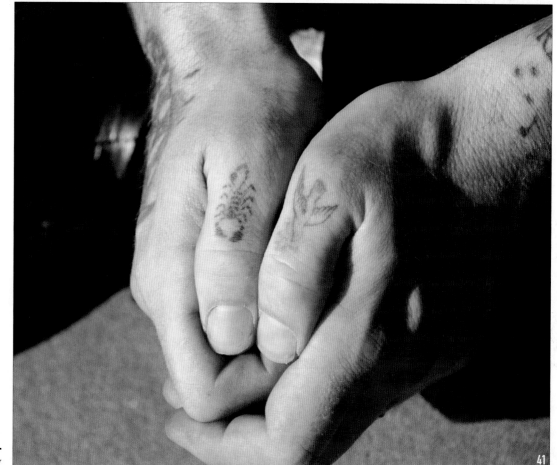

NATHEN MAXWELL
Flogging Molly

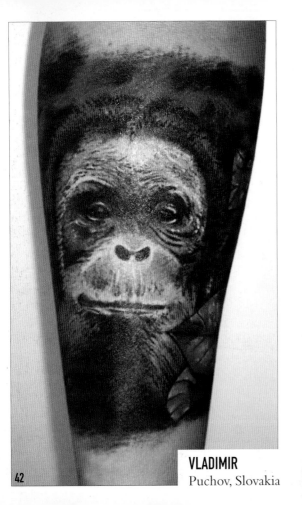

VLADIMIR
Puchov, Slovakia

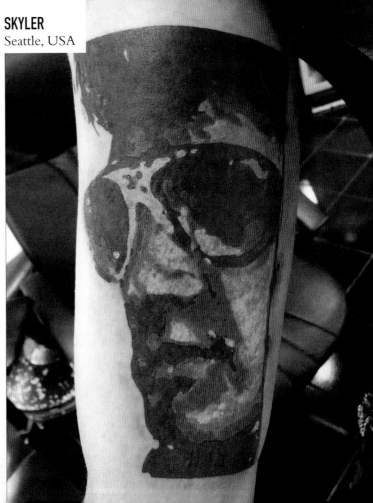

SKYLER
Seattle, USA

KAREN
Gateshead, UK

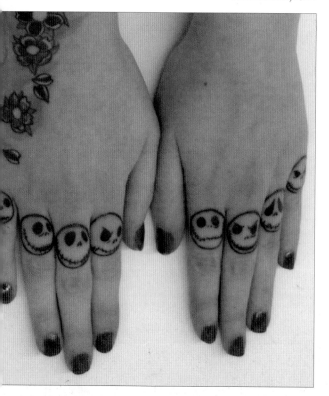

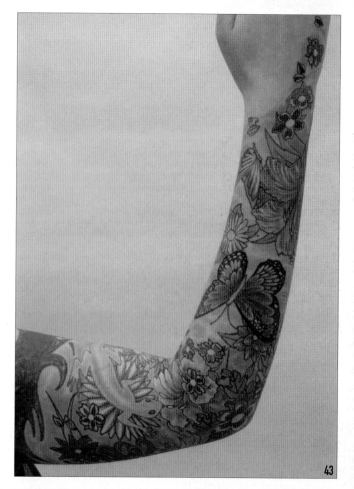

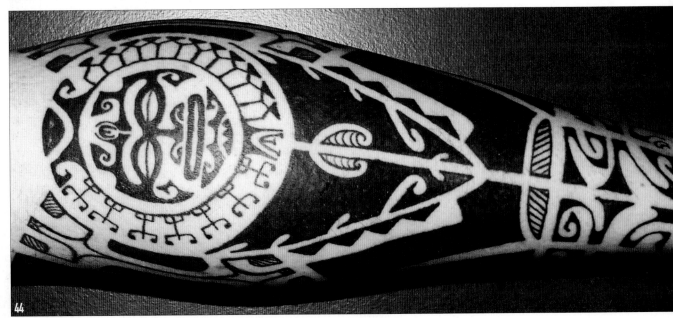

44

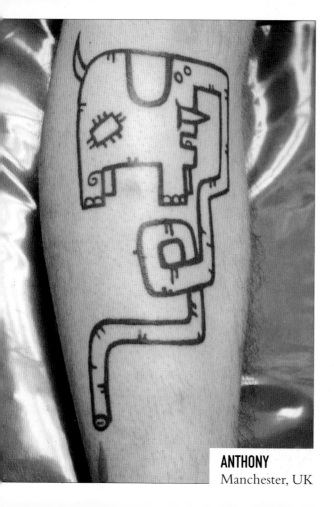

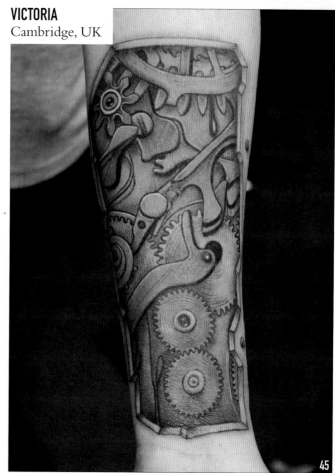

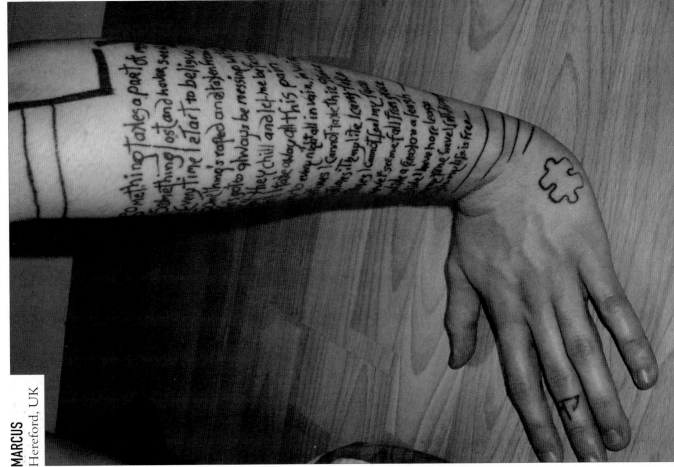

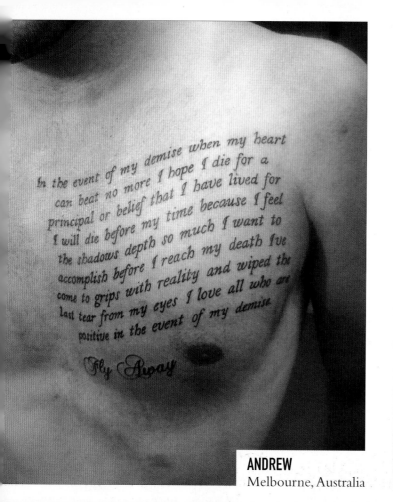

In the event of my demise when my heart
can beat no more I hope I die for a
principal or belief that I have lived for
I will die before my time because I feel
the shadows depth so much I want to
accomplish before I reach my death I've
come to grips with reality and wiped the
last tear from my eyes I love all who are
positive in the event of my demise

Fly Away

ANDREW
Melbourne, Australia

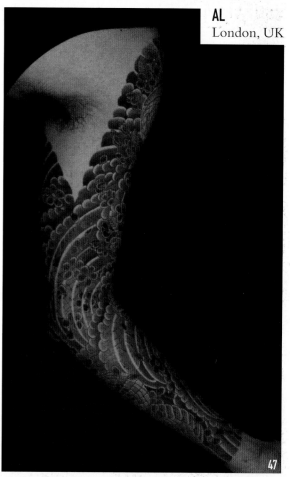

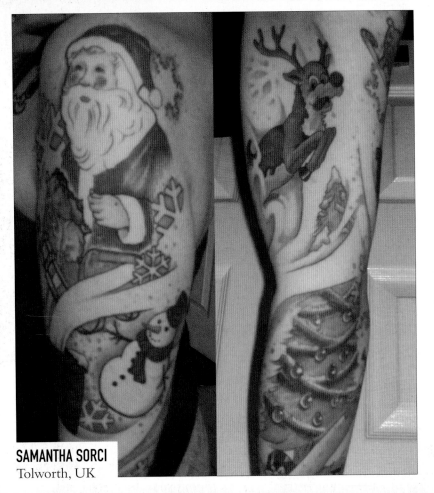

SAMANTHA SORCI
Tolworth, UK

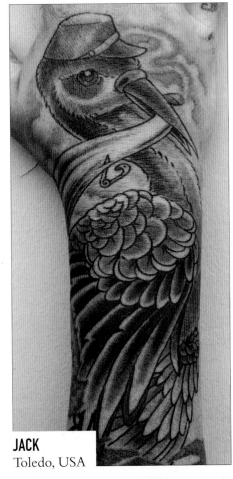

JACK
Toledo, USA

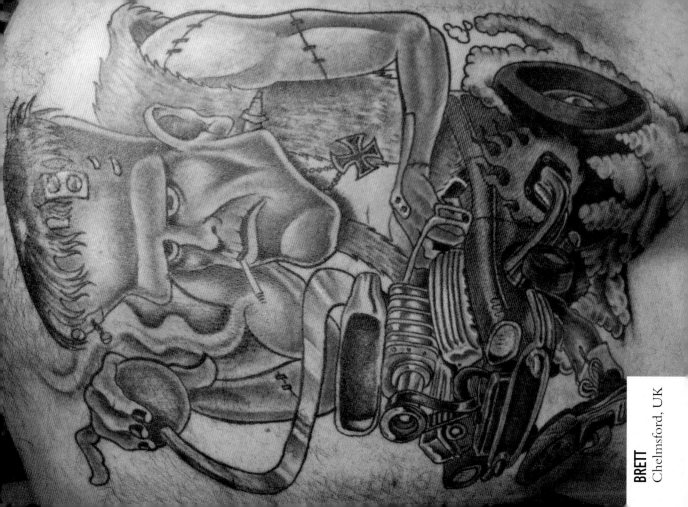

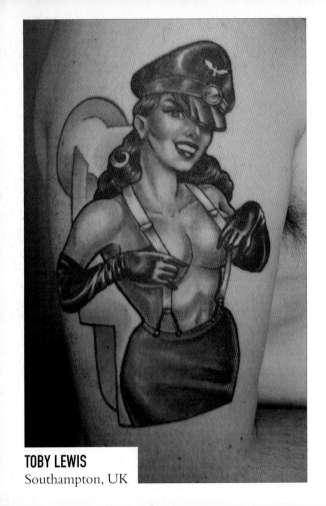

TOBY LEWIS
Southampton, UK

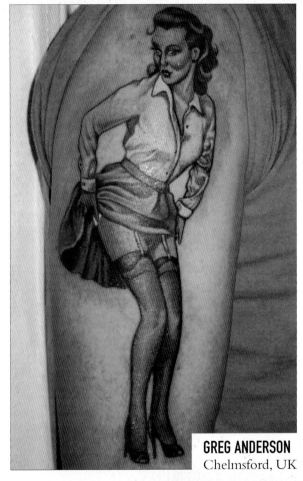

GREG ANDERSON
Chelmsford, UK

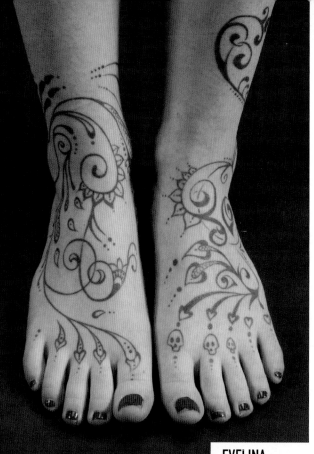

EVELINA
Shropshire, UK

MENNA PRITCHARD
Brighton, UK

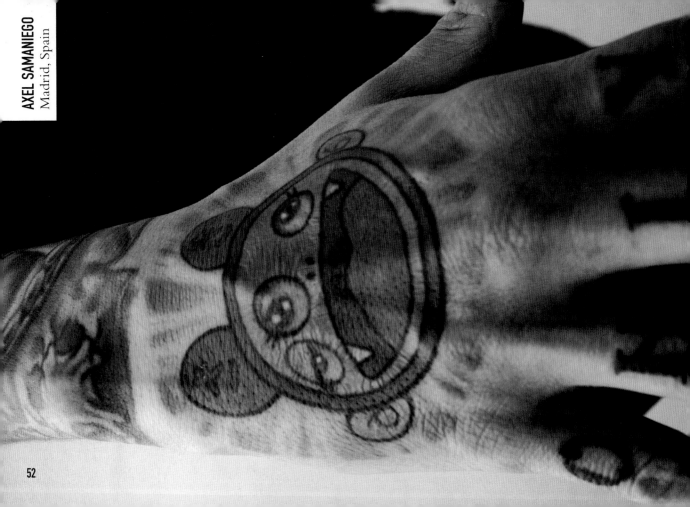

AXEL SAMANIEGO
Madrid, Spain

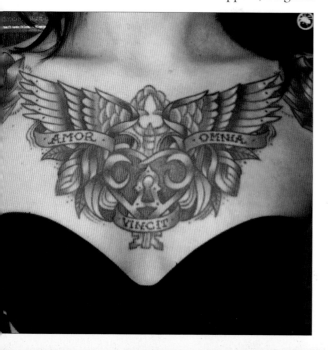

FEMKE VERSTRAETE
Loppem, Belgium

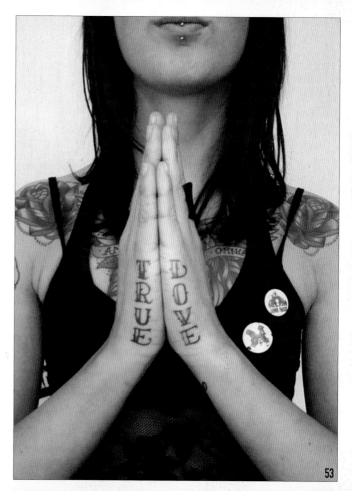

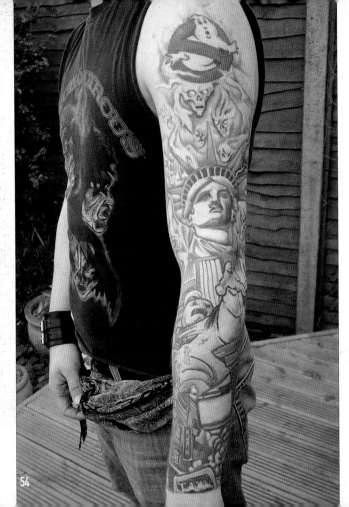

54

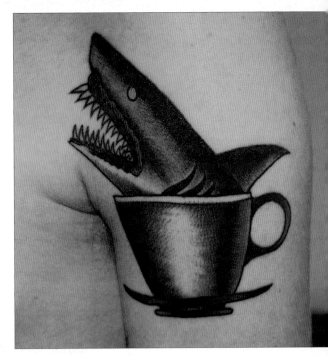

TOM HALE
Bury St Edmonds, UK

DAVE YOUNG
Kingston Upon Hull, UK

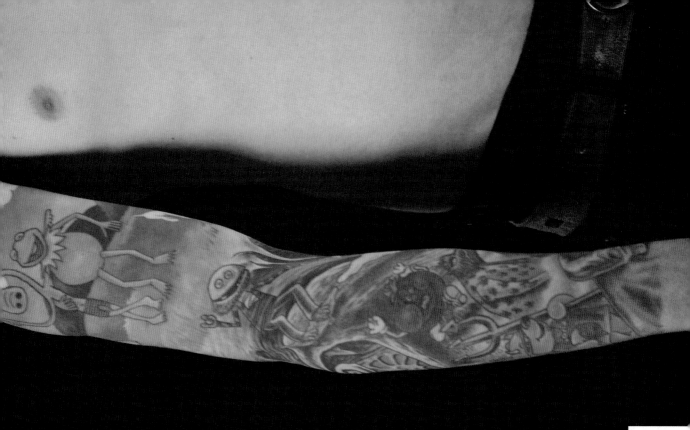

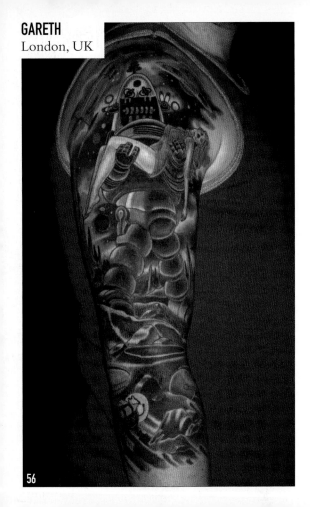

GARETH
London, UK

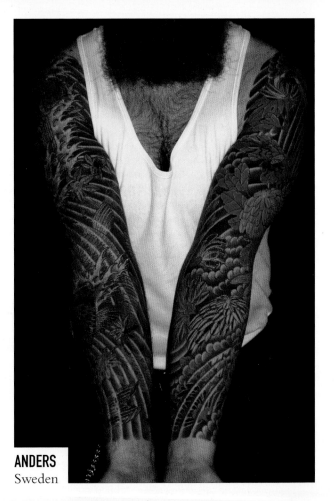

ANDERS
Sweden

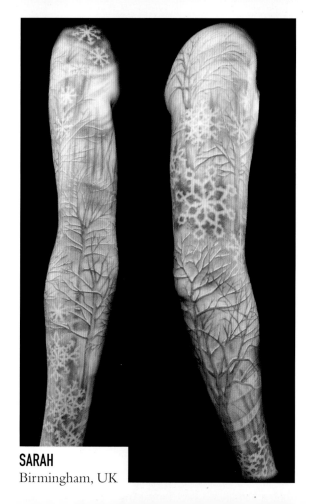

SARAH
Birmingham, UK

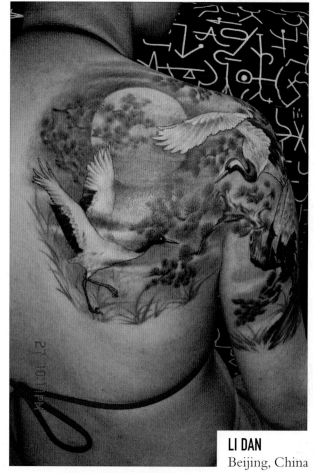

LI DAN
Beijing, China

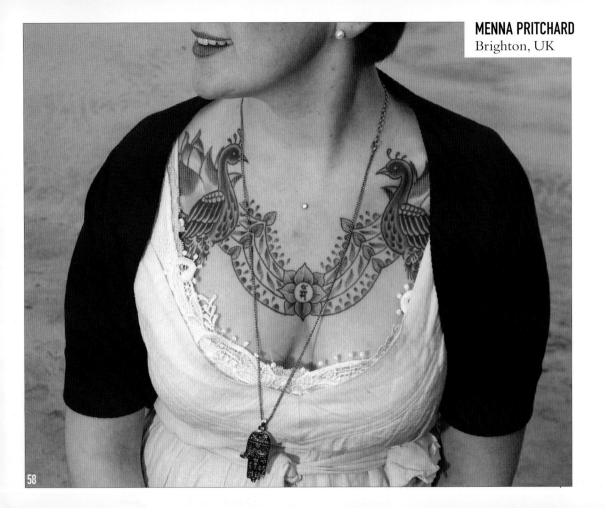

58

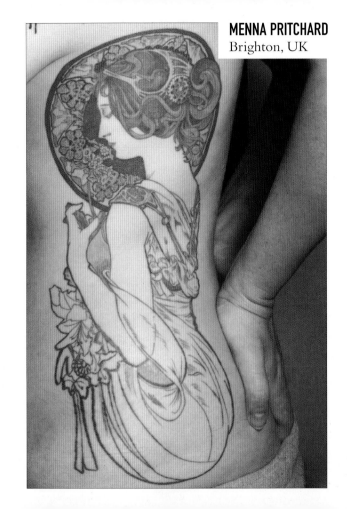

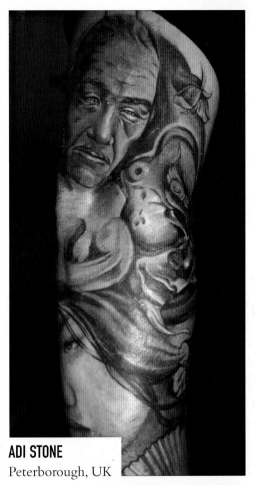

ADI STONE
Peterborough, UK

59

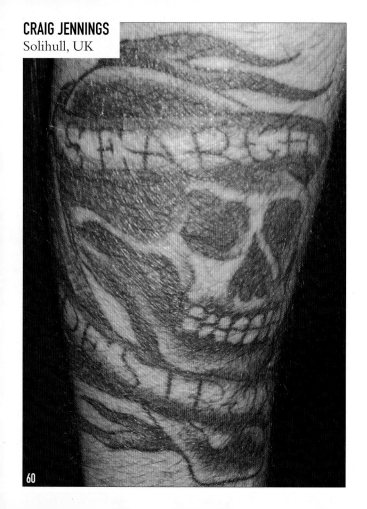

CRAIG JENNINGS
Solihull, UK

60

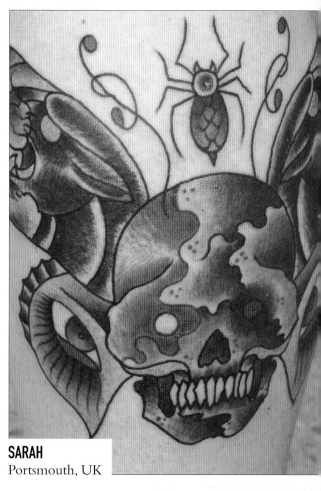

SARAH
Portsmouth, UK

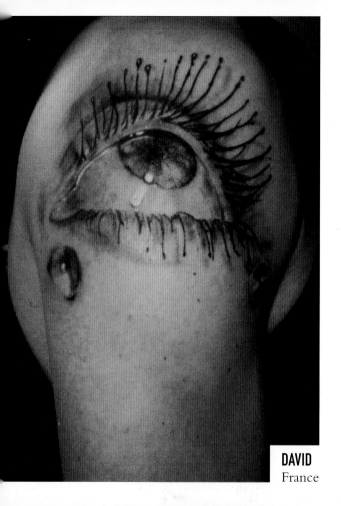

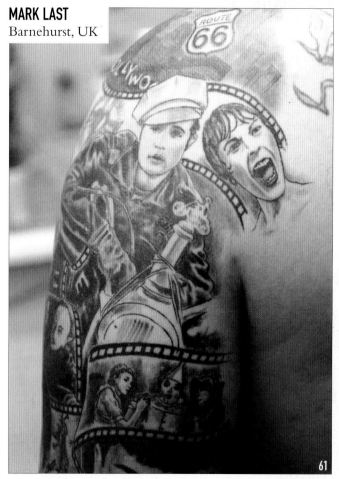

France

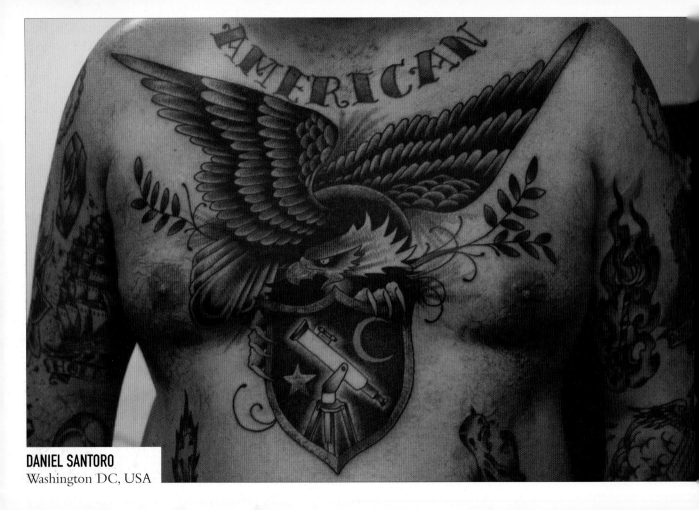

DANIEL SANTORO
Washington DC, USA

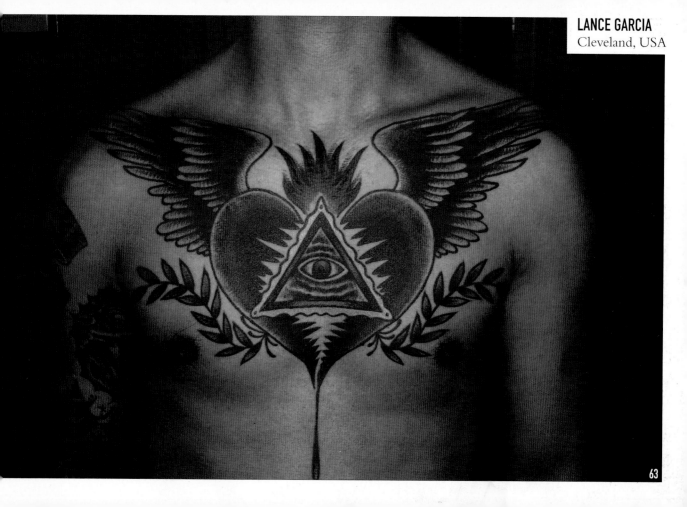

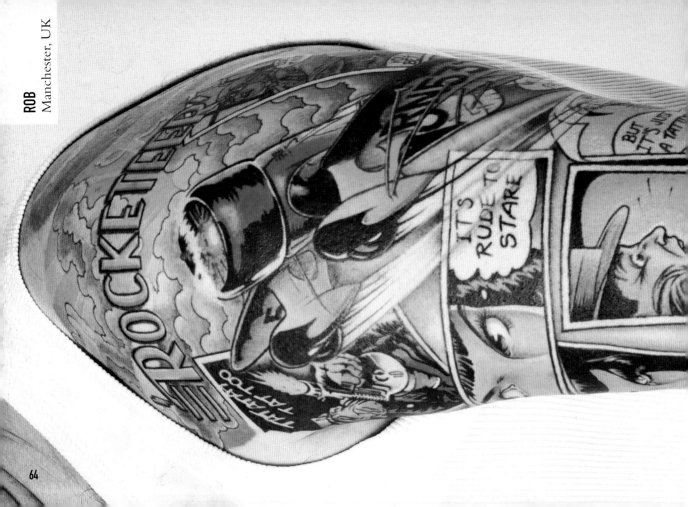

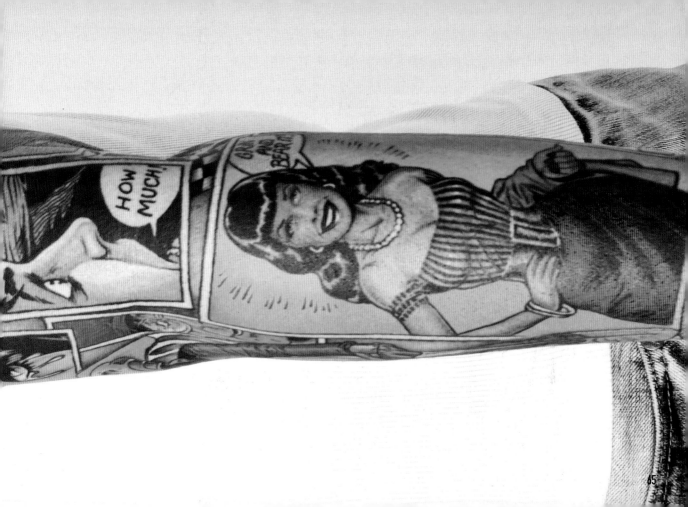

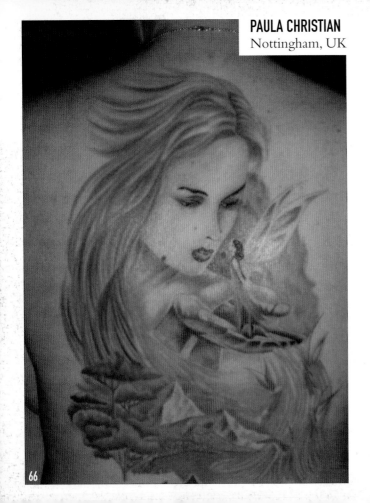

66

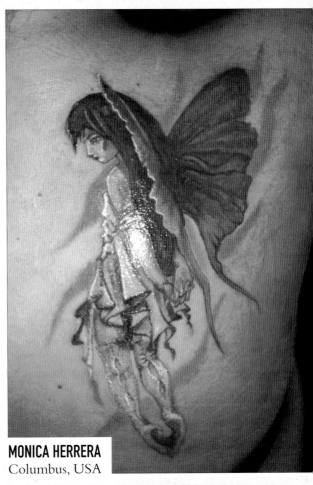

MONICA HERRERA
Columbus, USA

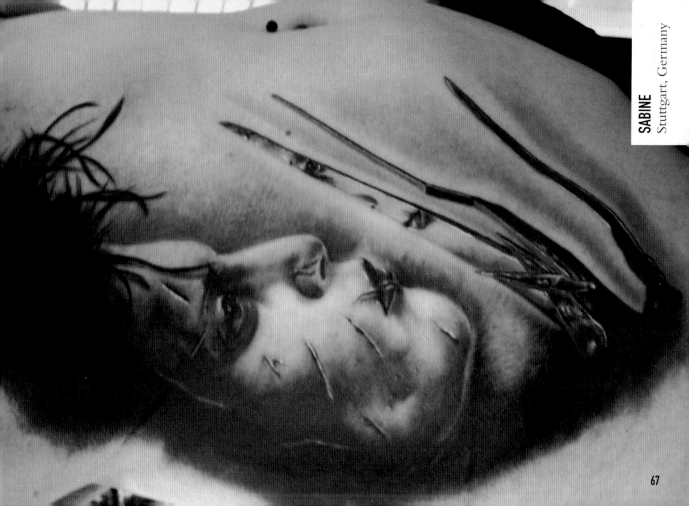

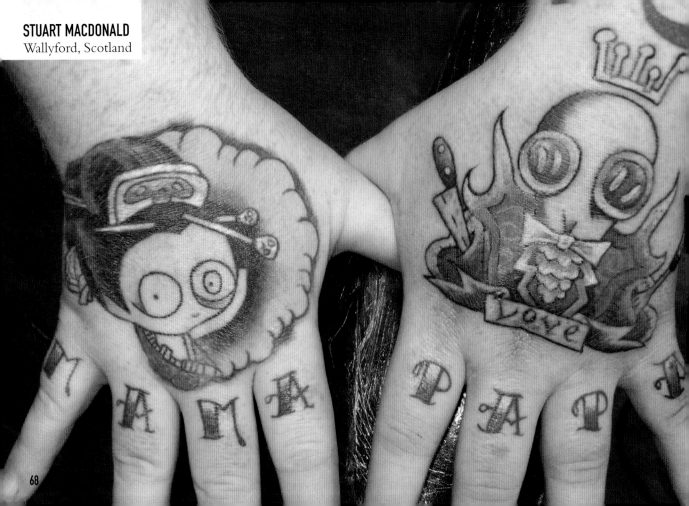

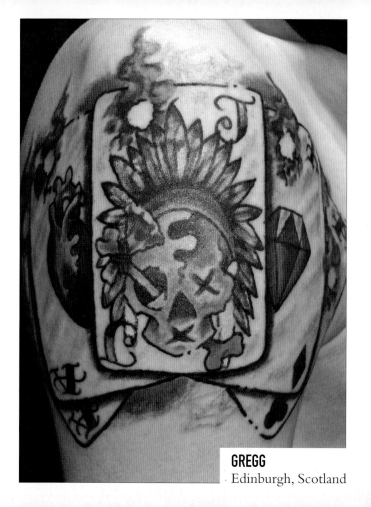

GREGG
Edinburgh, Scotland

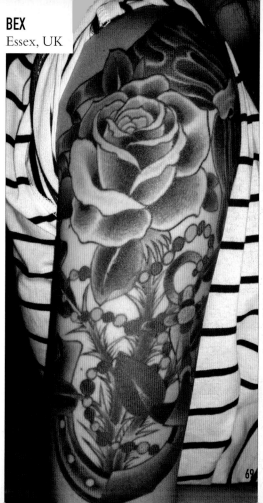

BEX
Essex, UK

69

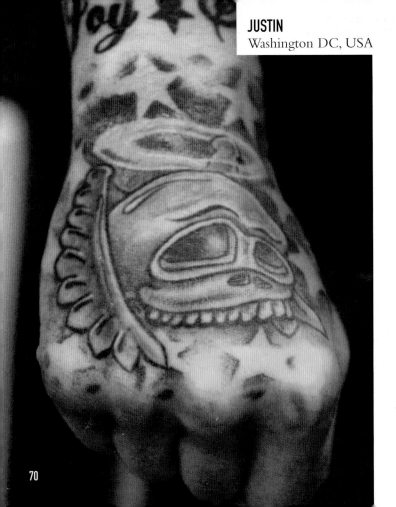

JUSTIN
Washington DC, USA

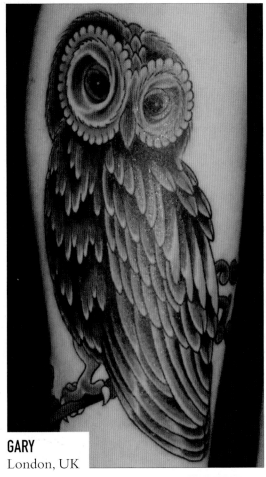

GARY
London, UK

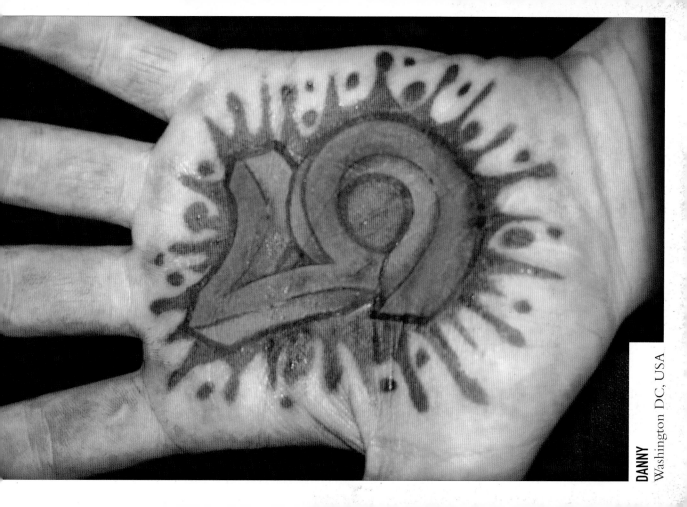

DANNY
Washington DC, USA

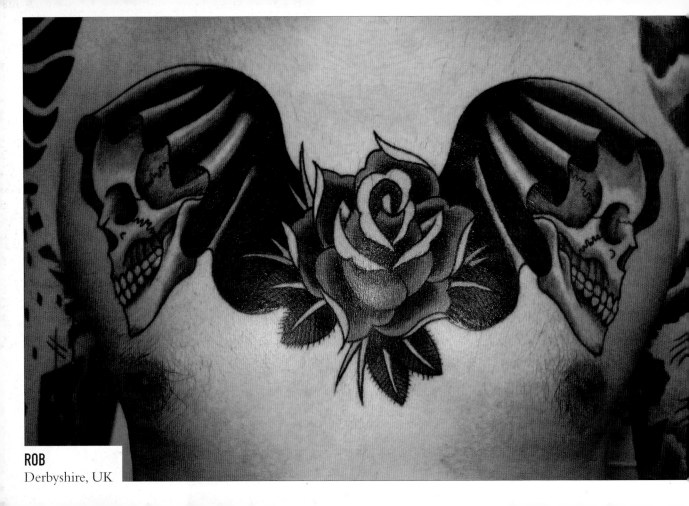

ROB
Derbyshire, UK

VASILIY
Moscow, Russia

GENA
Minsk, Belarus

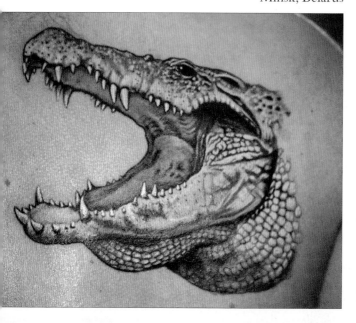

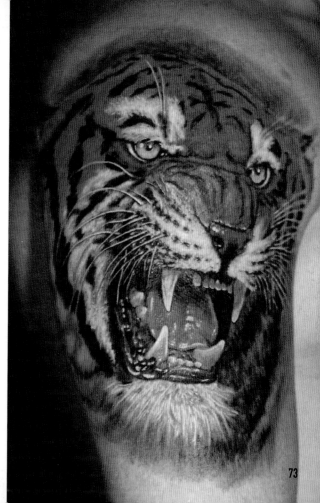

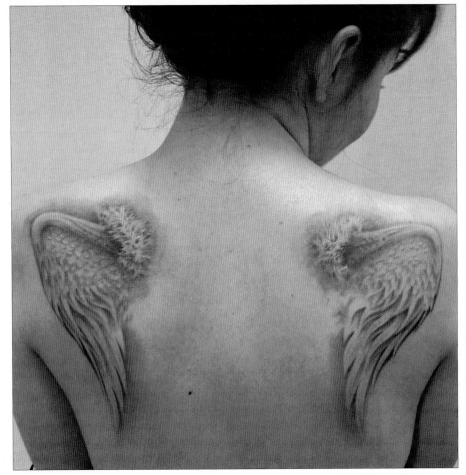

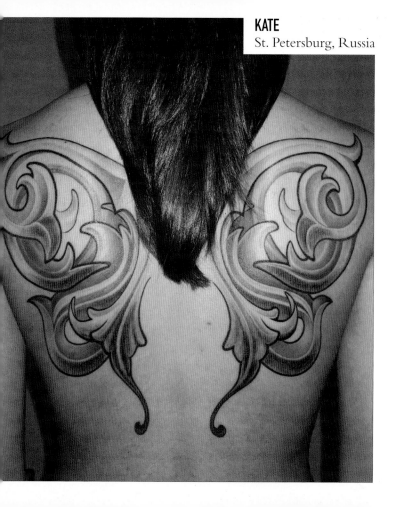

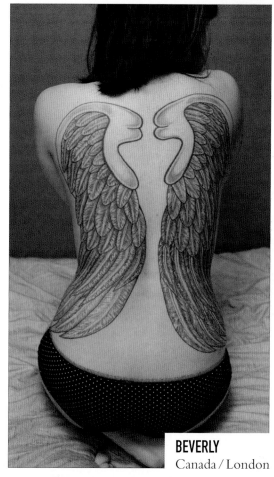

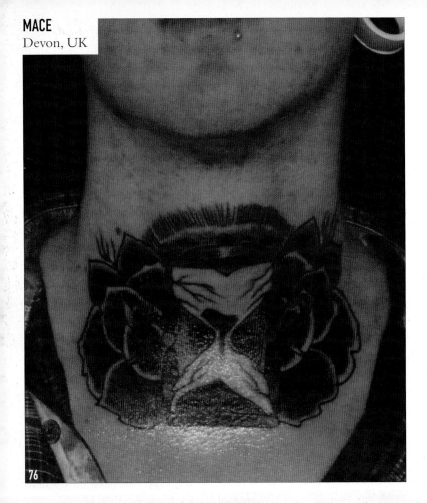

MACE
Devon, UK

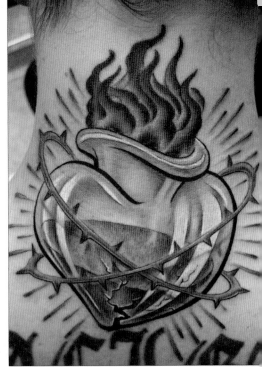

HECTOR JACKSON
Lowestoft, UK

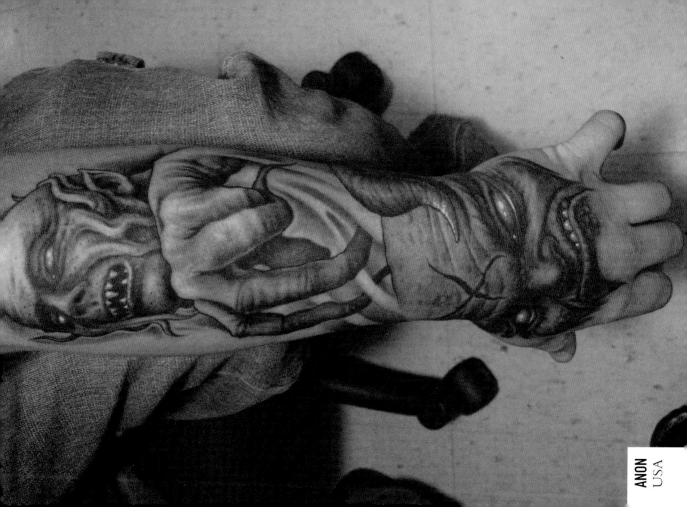

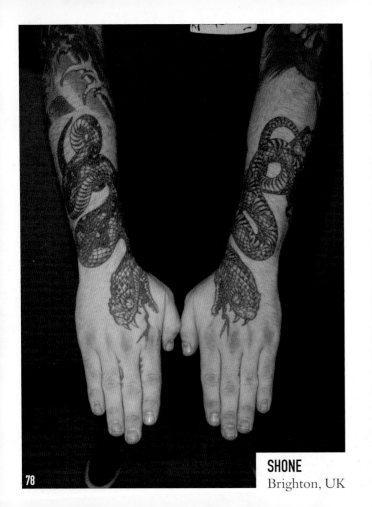

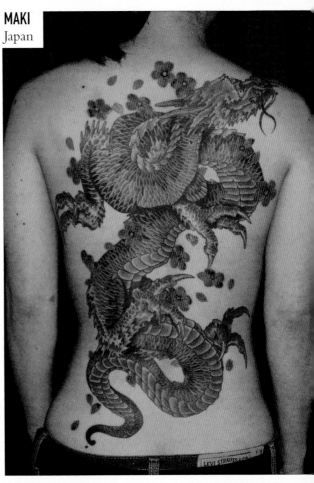

SHONE
Brighton, UK

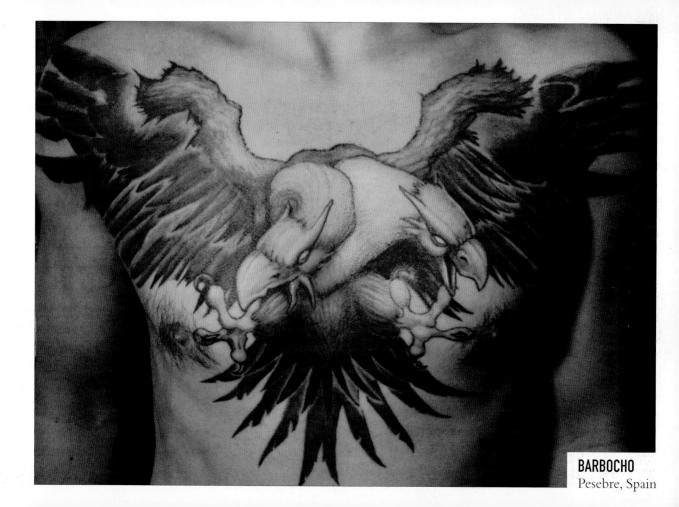

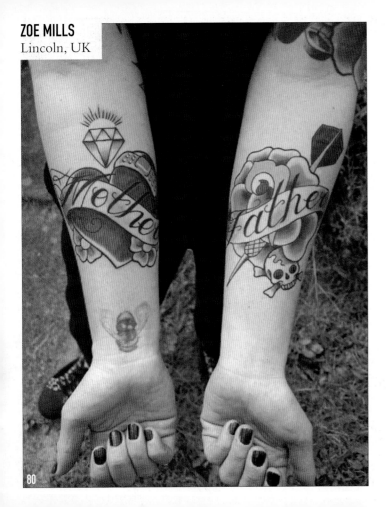

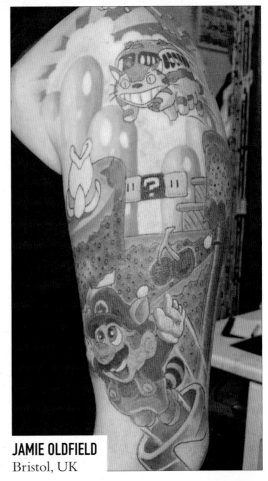

JAMIE OLDFIELD
Bristol, UK

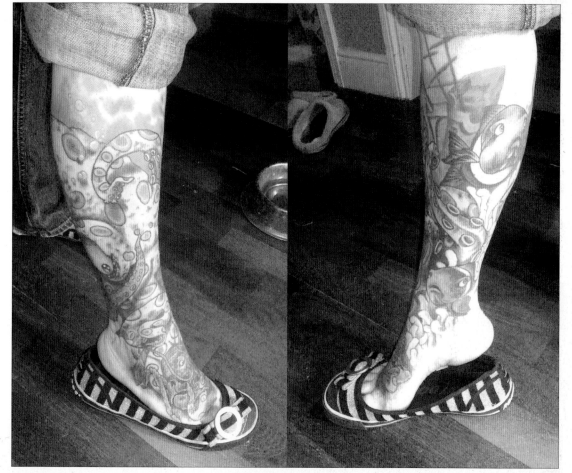

WHEEZEY
Norfolk, UK

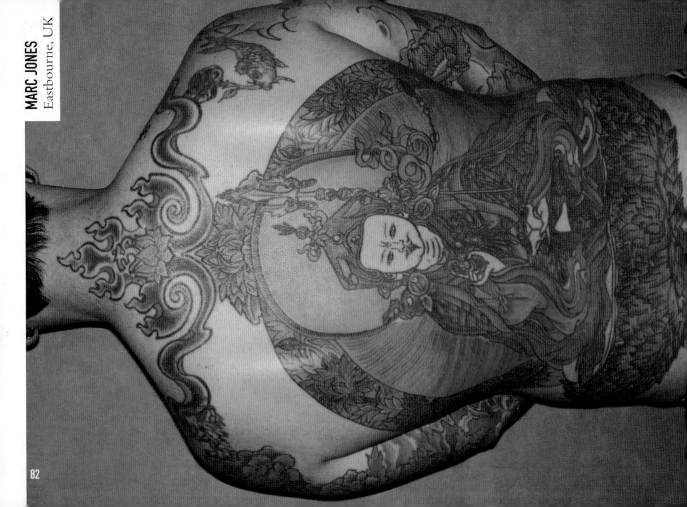

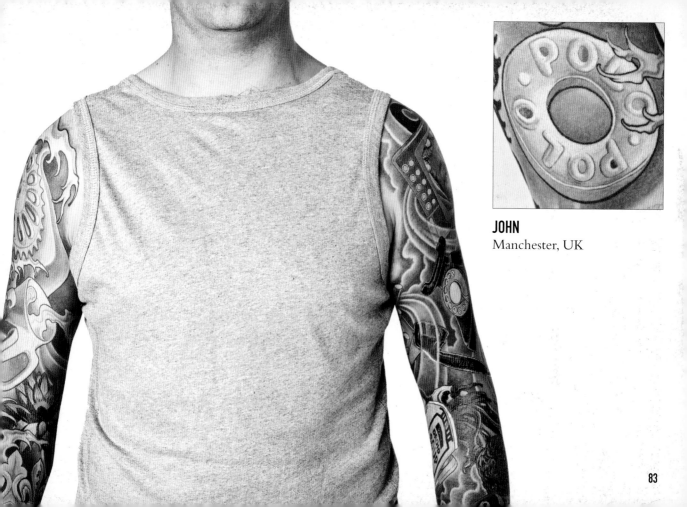

JOHN
Manchester, UK

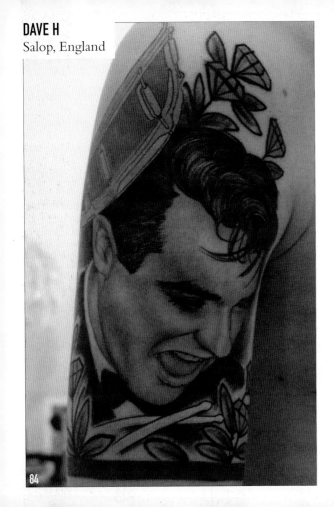

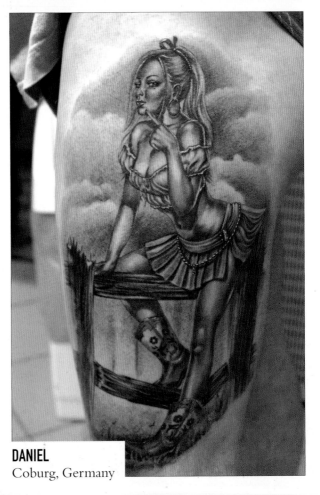

DANIEL
Coburg, Germany

SALLY
Todmorden, UK

JANE BURY
Lancashire, UK

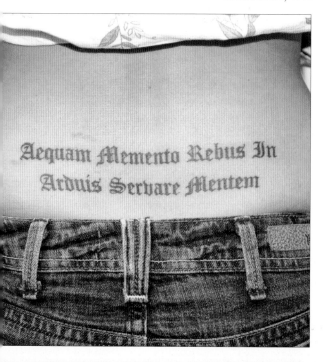

Aequam Memento Rebus In Arduis Servare Mentem

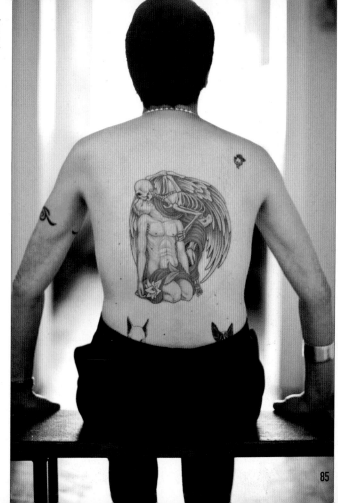

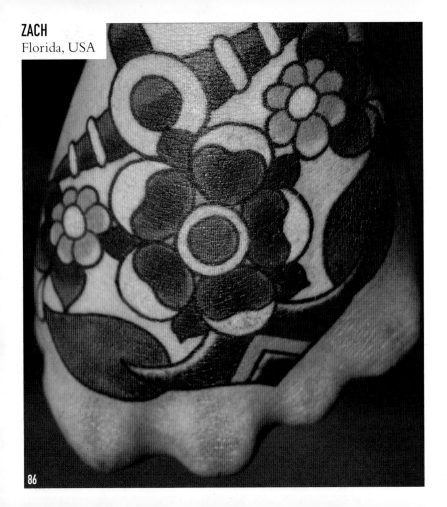

ZACH
Florida, USA

86

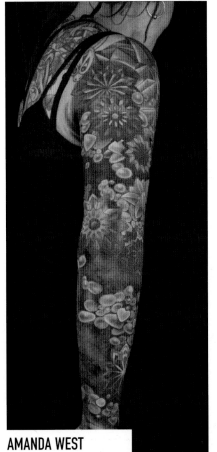

AMANDA WEST
Gloucestershire, UK

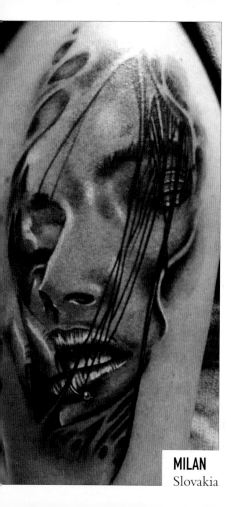

MILAN
Slovakia

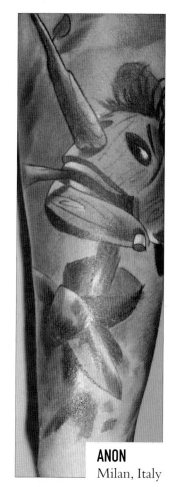

ANON
Milan, Italy

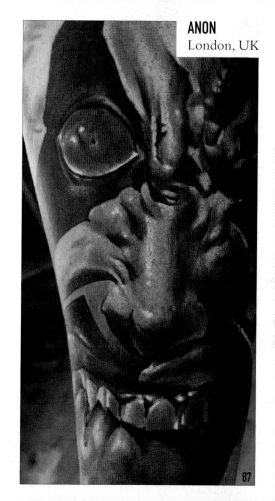

ANON
London, UK

87

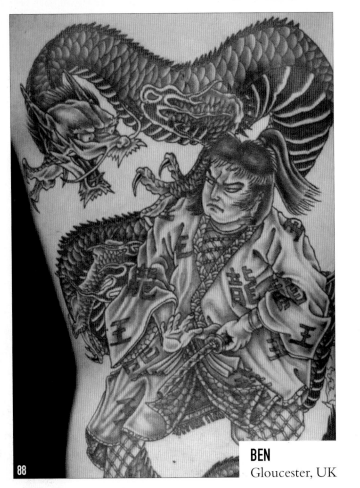

BEN
Gloucester, UK

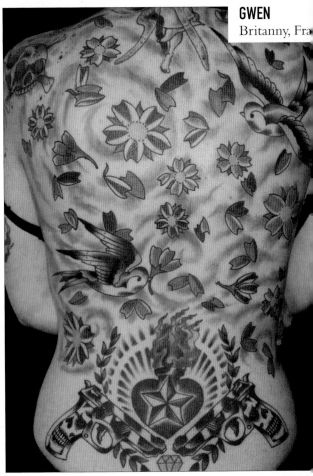

GWEN
Britanny, Fra

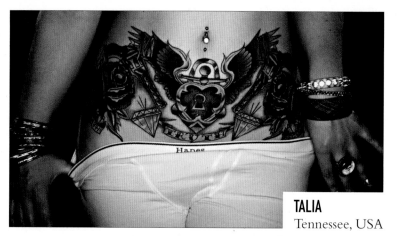

TALIA
Tennessee, USA

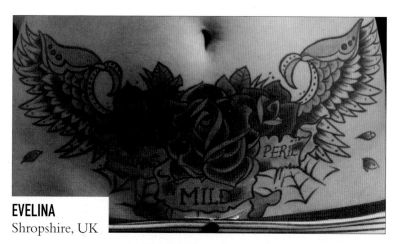

EVELINA
Shropshire, UK

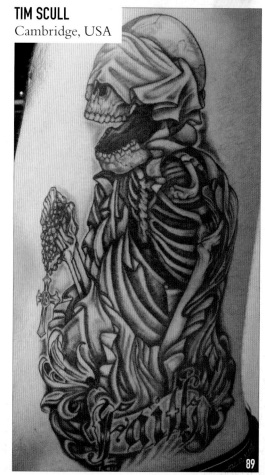

TIM SCULL
Cambridge, USA

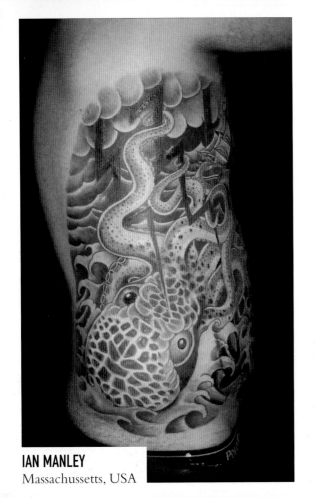

IAN MANLEY
Massachussetts, USA

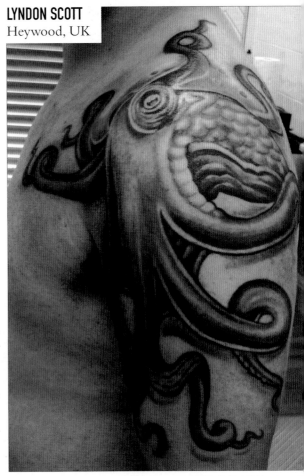

LYNDON SCOTT
Heywood, UK

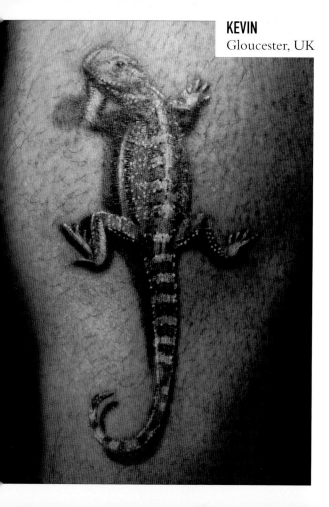

KEVIN
Gloucester, UK

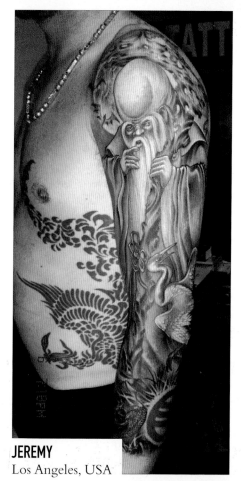

JEREMY
Los Angeles, USA

91

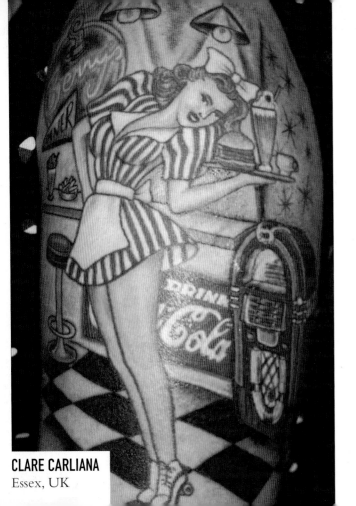

CLARE CARLIANA
Essex, UK

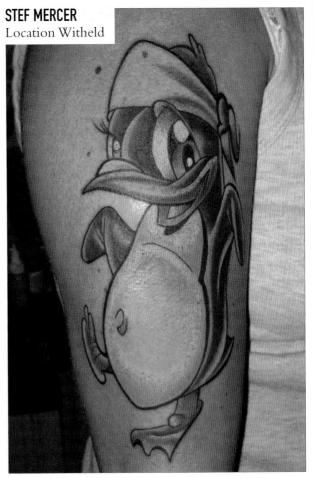

STEF MERCER
Location Witheld

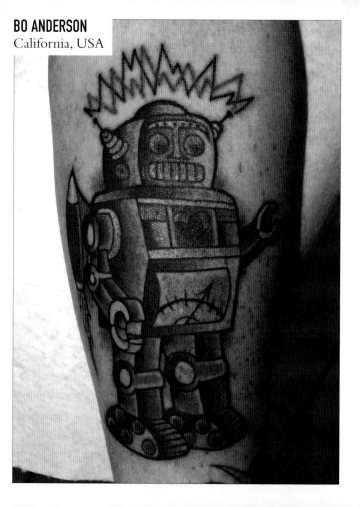

BO ANDERSON
California, USA

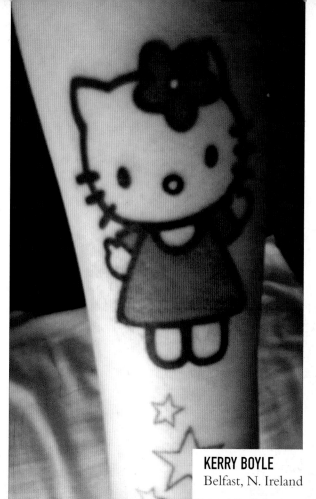

KERRY BOYLE
Belfast, N. Ireland

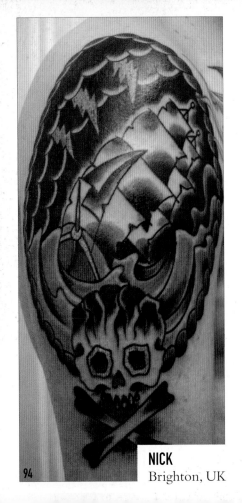

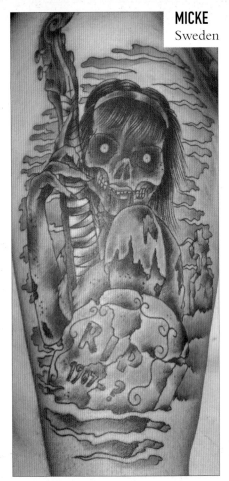

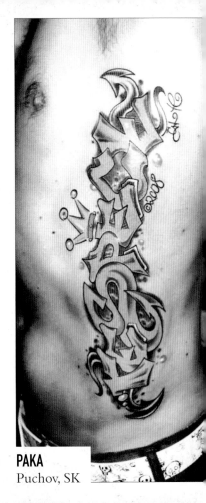

NICK
Brighton, UK

MICKE
Sweden

PAKA
Puchov, SK

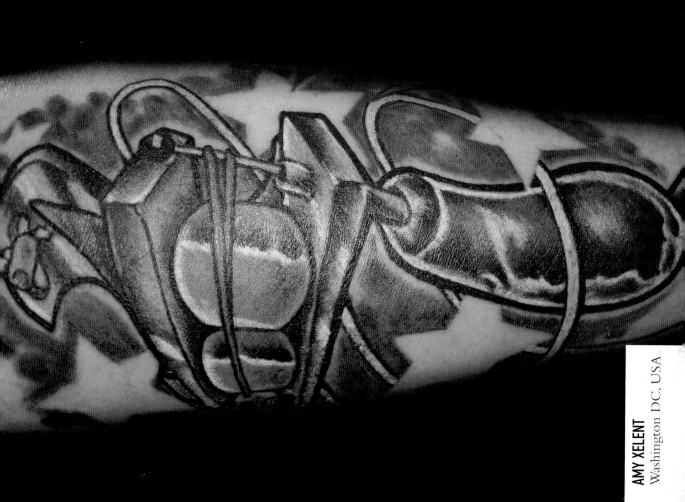

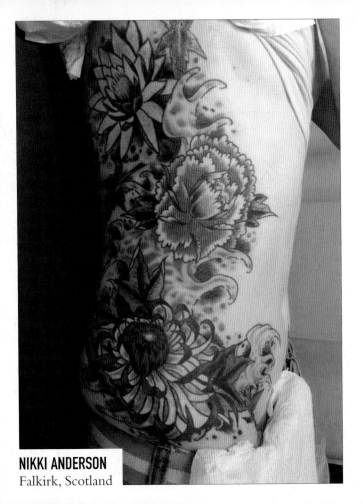

NIKKI ANDERSON
Falkirk, Scotland

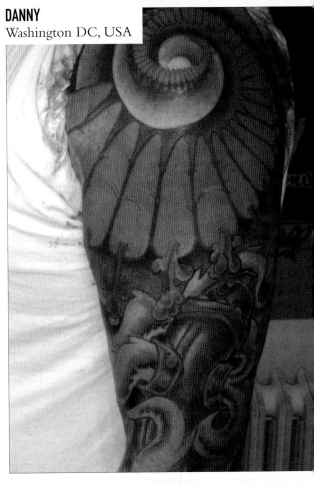

DANNY
Washington DC, USA

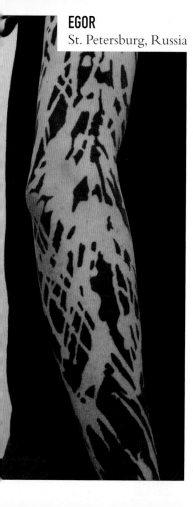

EGOR
St. Petersburg, Russia

MICHAEL
Location witheld

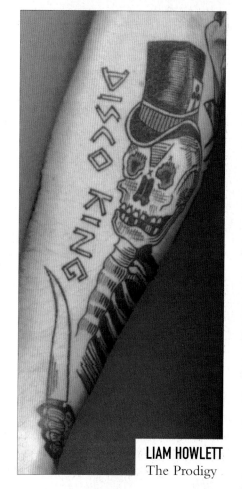

LIAM HOWLETT
The Prodigy

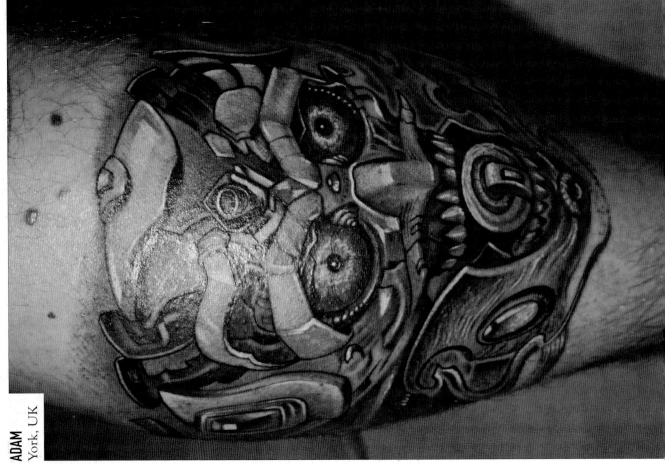

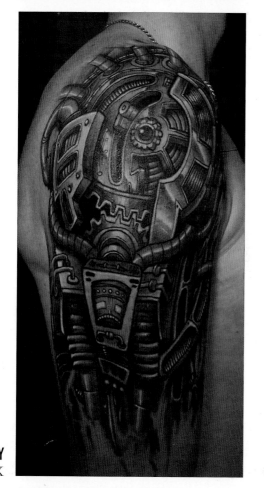

RORY
Shropshire, UK

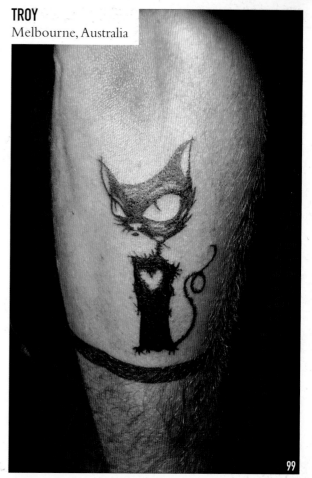

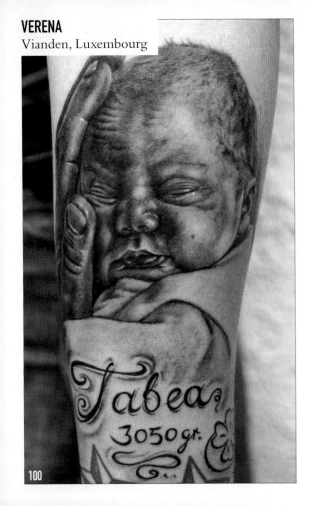

100

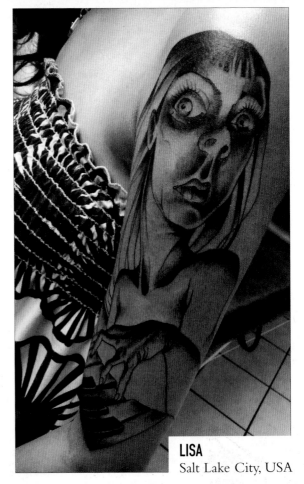

LISA
Salt Lake City, USA

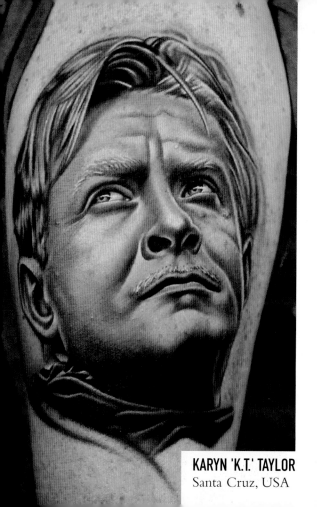

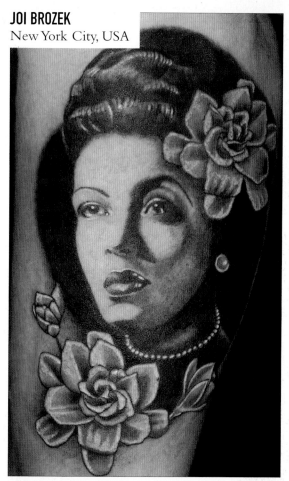

KARYN 'K.T.' TAYLOR
Santa Cruz, USA

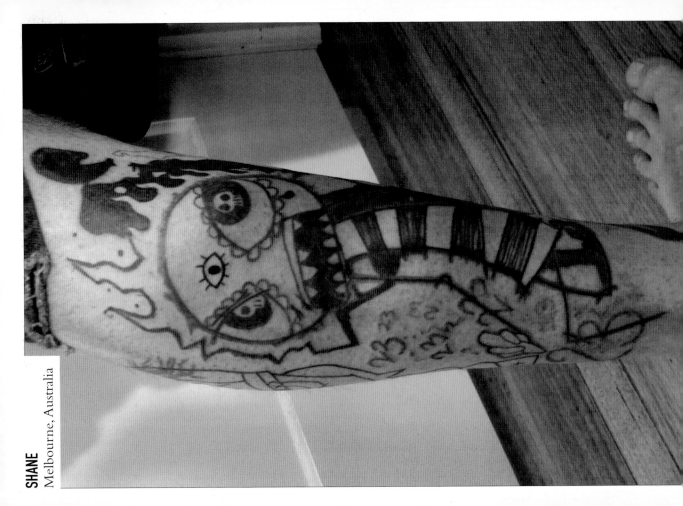

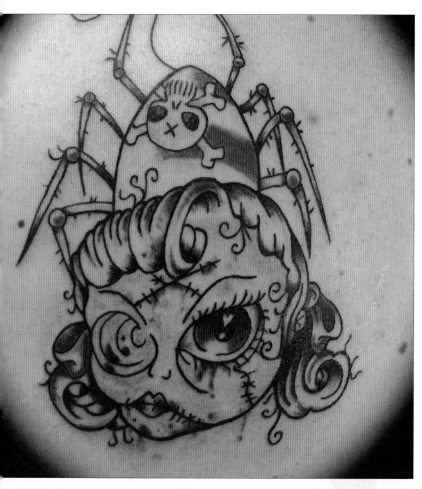

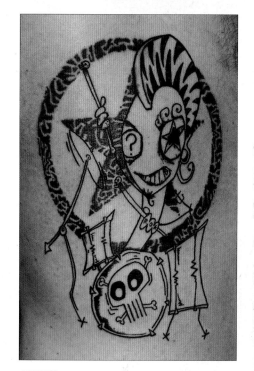

ADRIAN
Melbourne, Australia

ALISHA
Melbourne, Australia

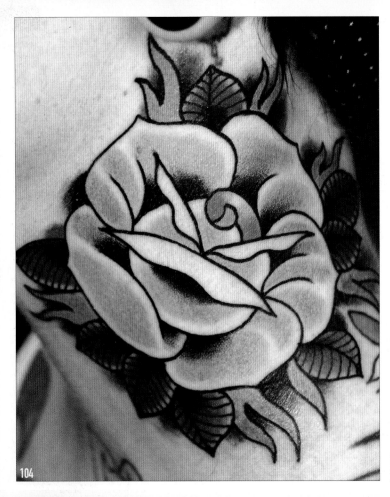

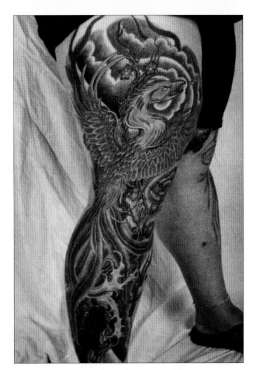

JO
Somerset, UK

HAYLEY
Nottingham, UK

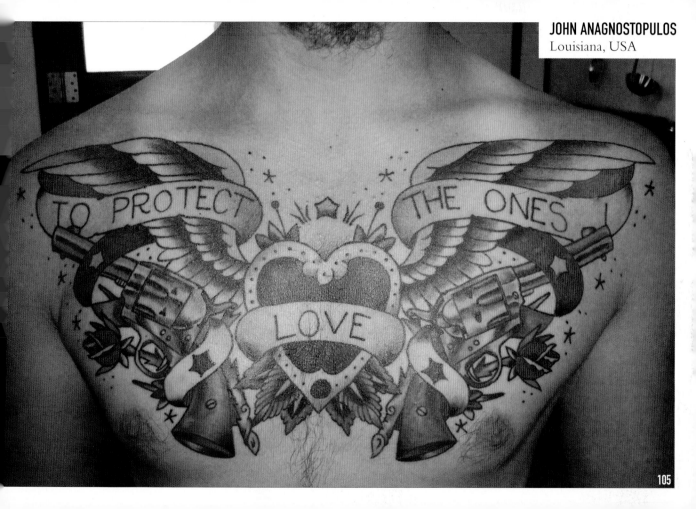

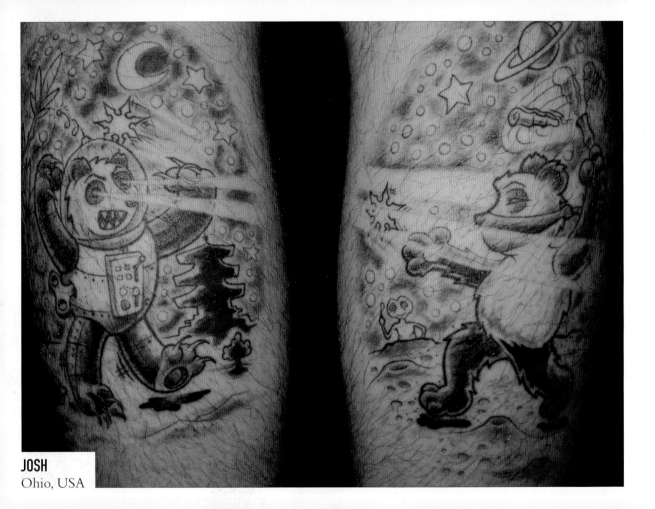

JOSH
Ohio, USA

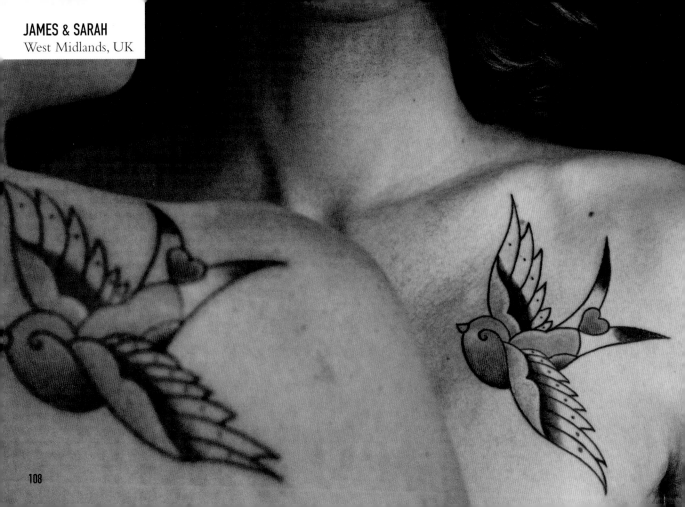

108

KIERON PEPPER
Essex, England

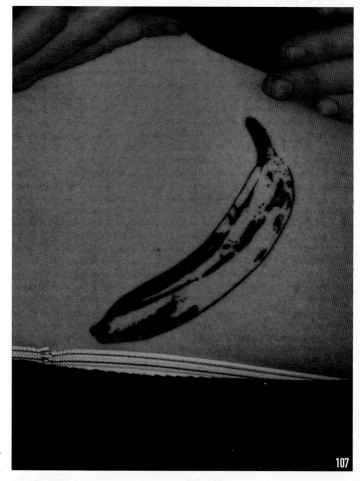

MICAELA MITCHELL
Hemel Hempstead, UK

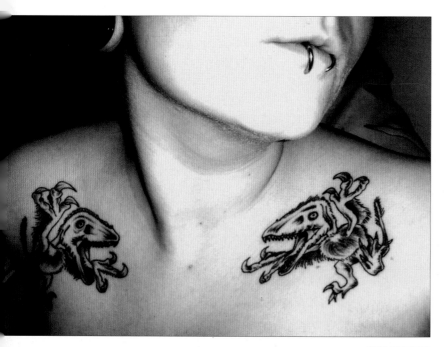

KAT FANTON
Brighton, UK

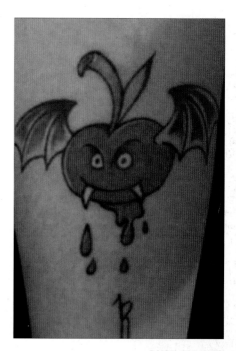

LUCY SUMNER
Liverpool, UK

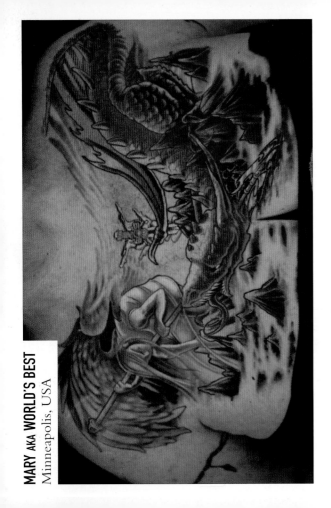

MARY aka WORLD'S BEST
Minneapolis, USA

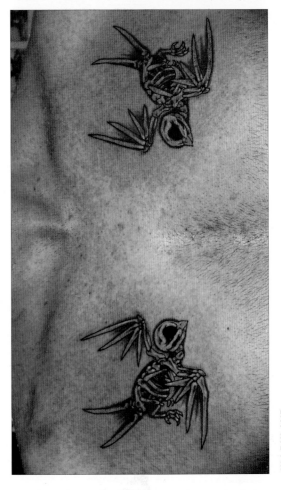

JIM RULAND
San Diego, USA

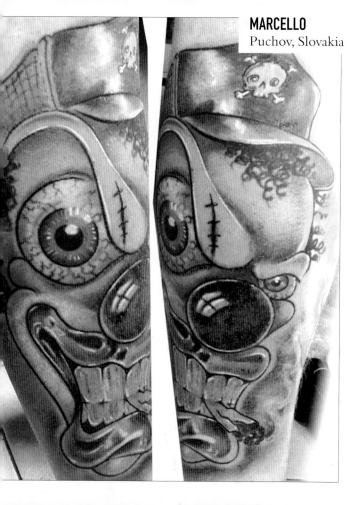

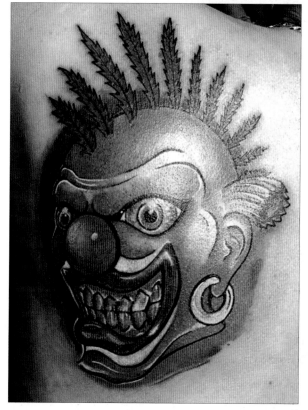

THC
Slovakia

111

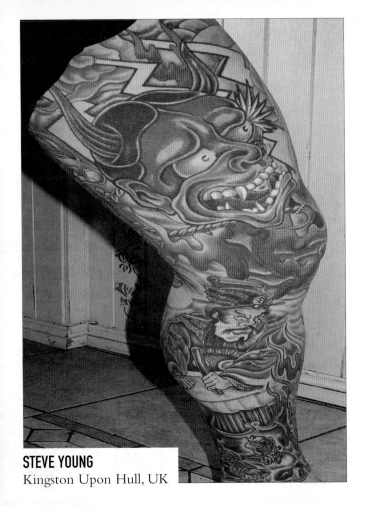

STEVE YOUNG
Kingston Upon Hull, UK

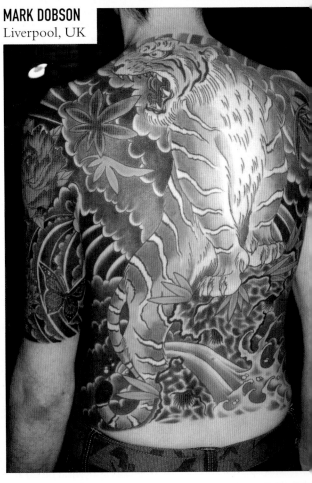

MARK DOBSON
Liverpool, UK

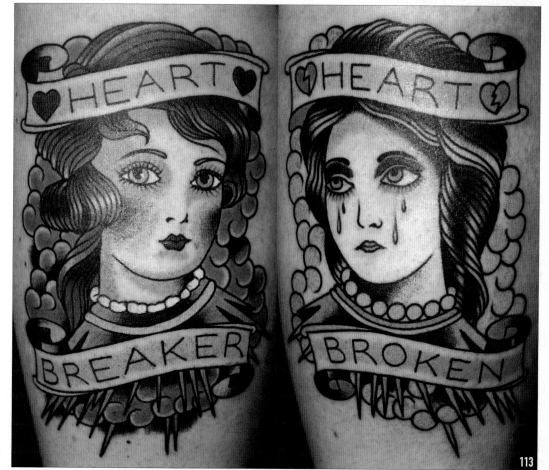

TASSY
Leeds, UK

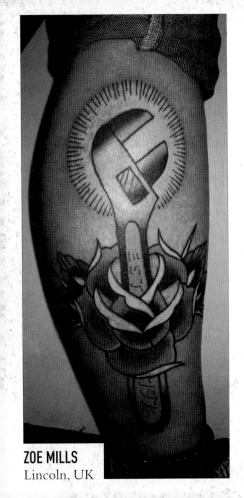

ZOE MILLS
Lincoln, UK

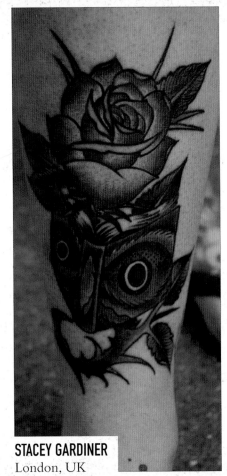

STACEY GARDINER
London, UK

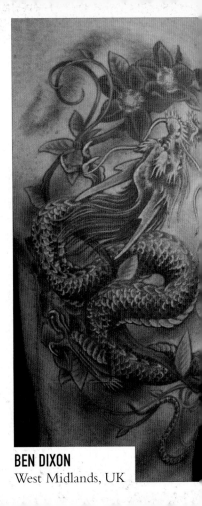

BEN DIXON
West Midlands, UK

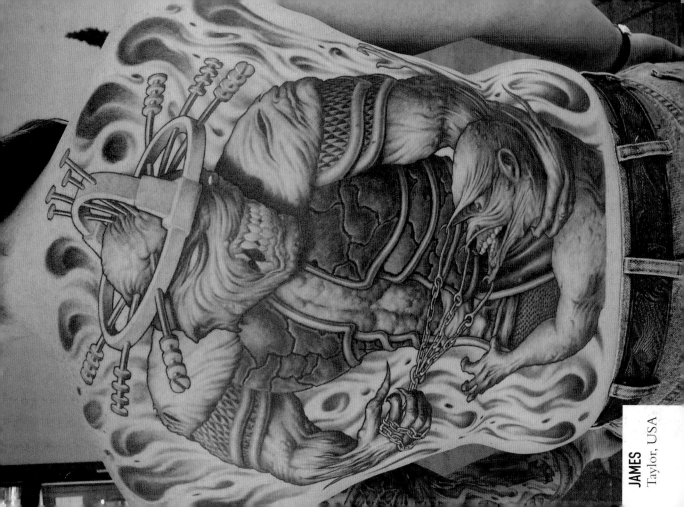

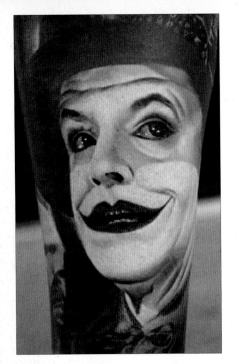
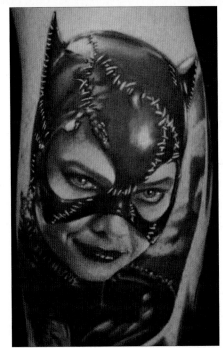
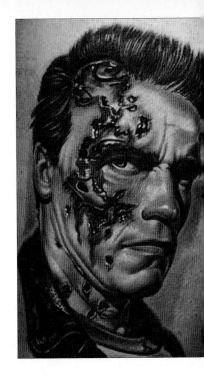

ROBERT HECKMAN
California, USA

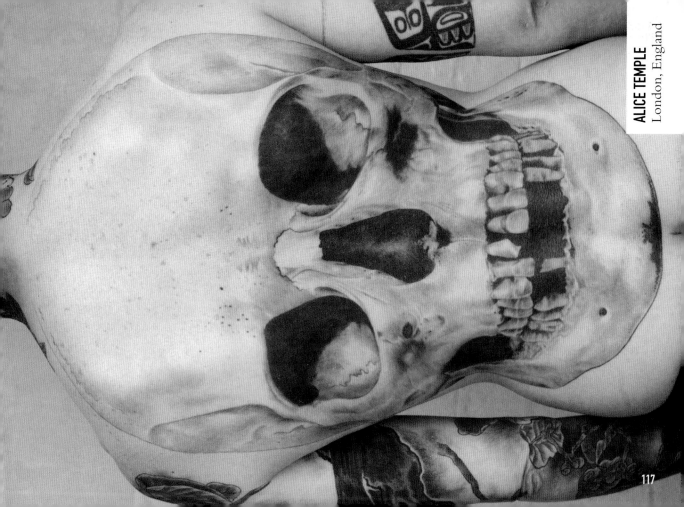

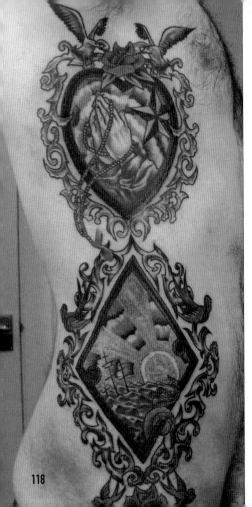

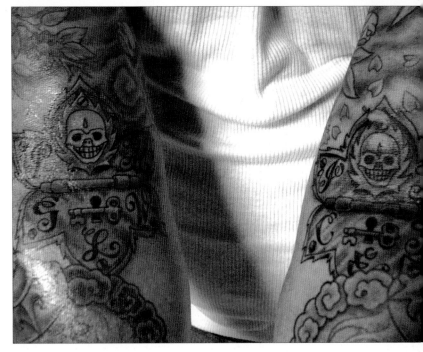

JEFF
Toledo, USA

MARTIN RILLO
Shetland, Scotland

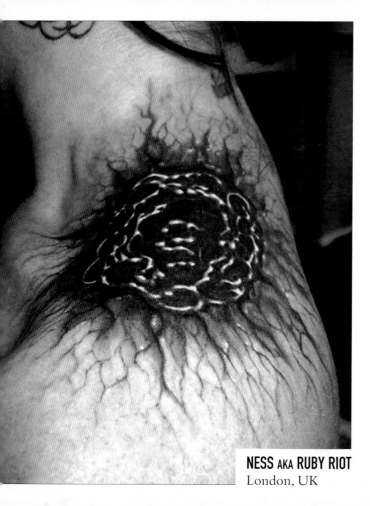

NESS AKA **RUBY RIOT**
London, UK

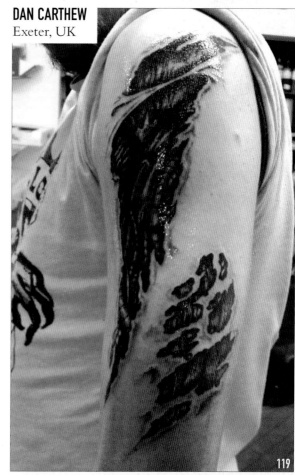

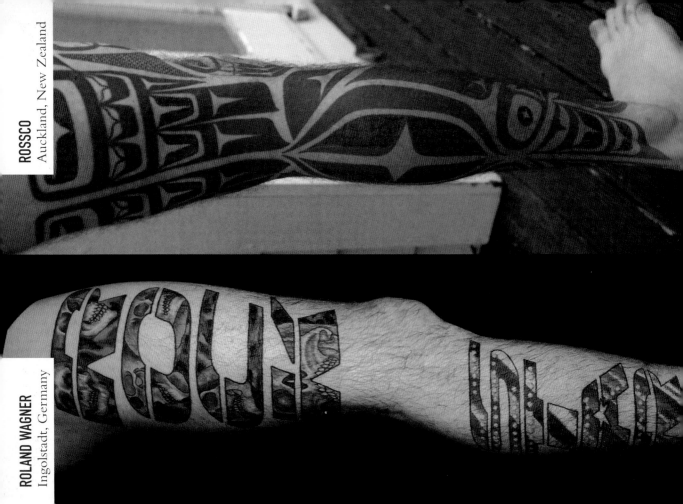

ROSSCO
Auckland, New Zealand

ROLAND WAGNER
Ingolstadt, Germany

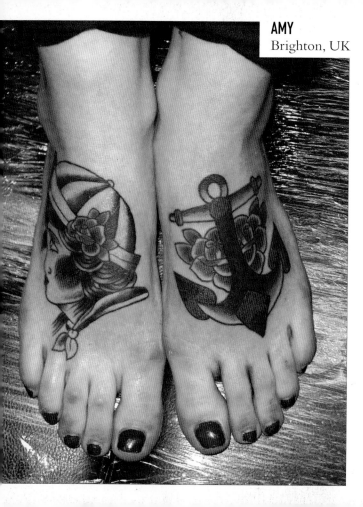

AMY
Brighton, UK

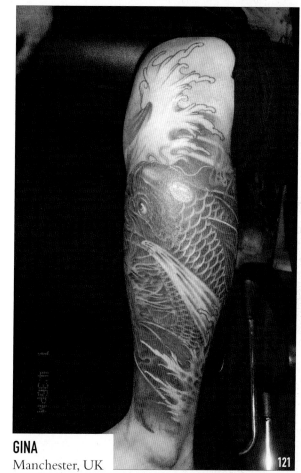

GINA
Manchester, UK

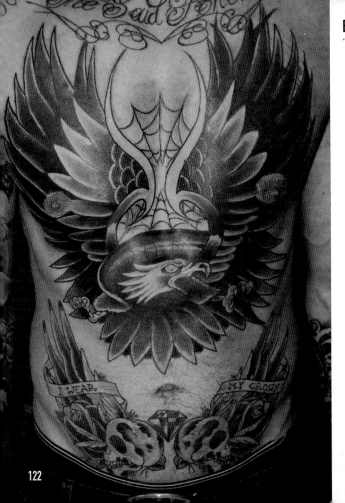

BEN BOYLE
Torquay, UK

BARRY TOTTMAN
Brixham, UK

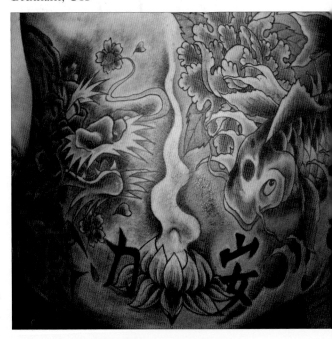

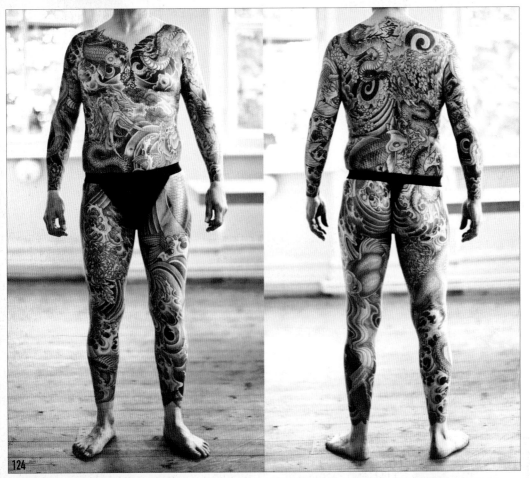

RAY
Manchester, UK

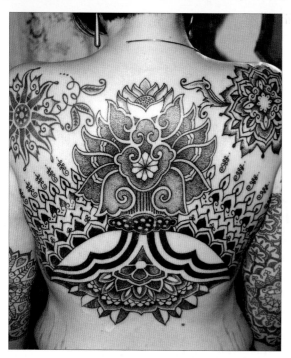

NIC ALLEN-SMITH
Devon, UK

LILIAN PARCHEN
Valley Village, USA

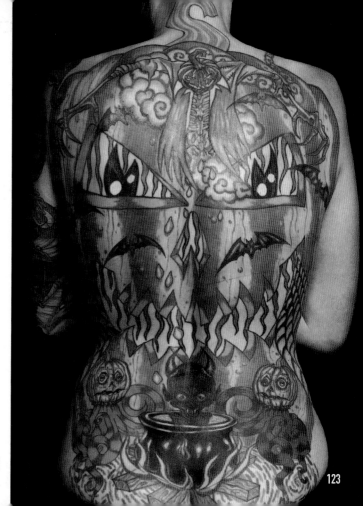

123

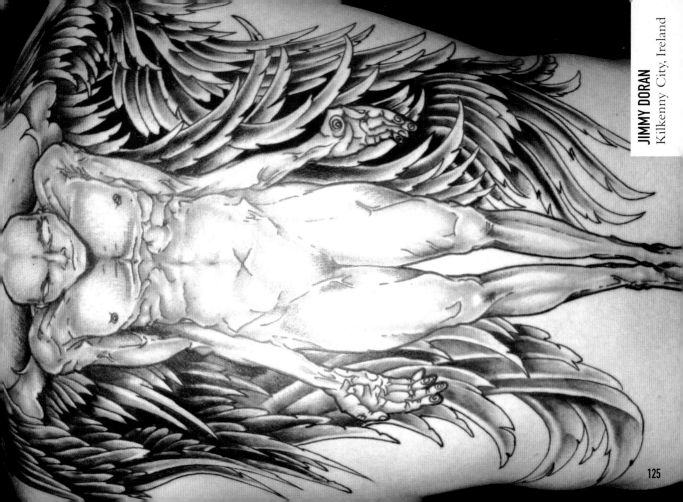

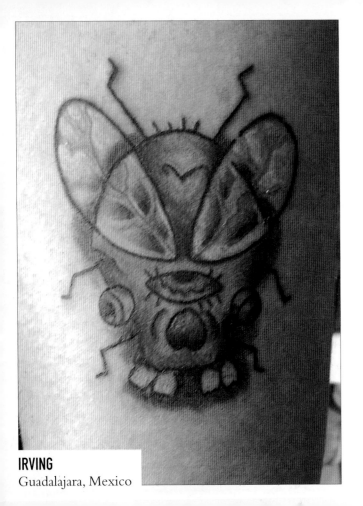

IRVING
Guadalajara, Mexico

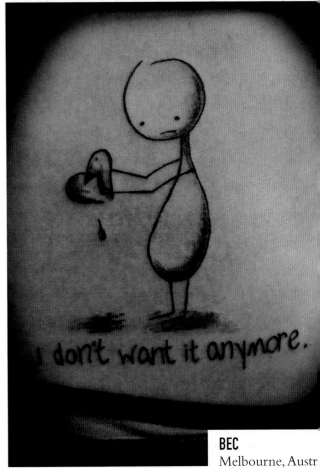

I don't want it anymore.

BEC
Melbourne, Austr

THE ARTISTS

The symbols used are to represent the tattoos location on the page.
(L) = Left,
(C) = Centre,
(R) = Right,
(T.L) = Top Left,
(B.L) = Bottom Left,
(T.R) = Top Right,
(B.R) = Bottom Right.

PAGE 4
Lynn, Brighton, UK.
Magnum Opus
www.magnumopus tattoo.com

PAGE 5
Nikki Canady, Harbinger, USA.
Dreamcatcher Soundside
www.myspace.com/ dreamcatchertat2

PAGE 6
Stuart Lambie, Ayr, Scotland. Monster Ink,
www.myspace.com/ tatustu666

PAGE 7
(L) Stuart Lambie, *(See page 6)*

(R) Frank, Southend, UK.

PAGE 8
West Coast Tattoo, Aberystwyth, Wales.
www.westcoast-tattoo.co.uk

PAGE 9
(L) Lea Nahon, Paris, France. Art Corpus
www.ontheroadtattoo. com

(R) Adam Harris, Brixham, UK.
New Tribe Tattoo
www.newtribetattoo. co.uk

PAGE 10
(L) Deano, St. Paul's Bay, Malta.
The Tat Shack
www.tatshack.biz

(R) Dawnii, Birmingham, UK.
Painted Lady Tattoo Parlour
www.paintedladytattoo. co.uk

PAGE 11
Mikey Bolahood, Uxbridge, Ontario, Canada.
Living Ink

PAGE 12
Saira Hunjan, London. The Family Business
www.thefamilybusinesstattoo.com

PAGE 13
Jo Harrison, Birmingham, UK.
Modern Body Art
www.modernbodyart.co.uk

PAGE 14
Phil Kyle, England.
Magnum Opus Tattoo
www.magnumopustattoo. com

PAGE 15
Marianna, Traversetolo, Italy. Lulù Tattoo

PAGE 16
Andy Edge, UK.
www.myspace.com/ doomink

PAGE 17
No details available.

PAGE 18 / 19
Bob Tyrell, Michigan, USA.
www.bobtyrell.com

PAGE 20
Filip Leu, Lausanne, Switzerland. The Leu Family's Family Iron

PAGE 21
(L) Trista Marie, Milwaukee, Wisconsin, USA. Custom Tattoo
www.custom-tattoo.net

(R) Chad Koeplinger, Washington DC, USA.
Tattoo Paradise
www.tattooparadisedc.com

PAGE 22
(L) Leigh Brydges, Hull, UK. BodyArt

PAGE 23
(R) Originally: Saz Saunders/Reworked: Louis Molloy
Middleton Tattoo Studio, UK.
www.tattoos.co.uk

PAGE 23
Ben Stone, Derby, UK.
Lifetime Tattoo
www.lifetimetattoo.co.uk

PAGE 24
Phil Kyle, *(See Page 14)*

PAGE 25
(L) Jason Rhodes, Mt. Pleasant, Michigan, USA.
Intricate Décor Tattoos
www.intricatedecortattoos. com

(R) Lisa Dowling, Canada.

PAGE 26
Yang Zhuo, Beijing, China.
www.chinayztattoo.com

PAGE 27
Randy Janson, San Diego, USA.
2 Roses Tattoo
www.2rosesinc.com

PAGE 28
(T.L) Matt Hugill,

(T.R) Tuesday Rooke

(B.L) Tuesday Rooke

(B.R) Matt Hugill

Tattoo UK, Uxbridge, UK.
www.tattoouk.com

PAGE 29
(L) Adam Harris, *(See Page 9)*

(R) Matt Hugill, *(See Page 28)*

PAGE 30
(L) Seven Beckham, Edmonton, Alberta, Canada.
Eye Of The Lotus
www.sevenbeckham.com

(R) Adam Harris, *(See Page 9)*

PAGE 31
(L) Sween, UK.
21st Century Tattoo
www.tattoos-by-sween.com

(R) Adam Harris, *(See Page 9)*

PAGE 32
Andy Engel, Kitzingen, Germany. Andy's Tattoo & Piercing Studio
www.andys-tattoo.com

PAGE 33
(L) Emma Grech, Portsmouth, UK.
Lady Luck Tattoo Studio

(R) Chris Hatton, Cardiff, Wales.
Physical Graffiti

PAGE 34
(L) Atenna Lee, Guadalajara, Jalisco, Mexico.
www.myspace.com/ rotted_cherry

(R) Andy Morris, Sedgley, England.
Native Ink Tattoo Studio
www.nativeink.co.uk

PAGE 35
(L) Louis Molloy, Middleton, UK.
Middleton Tattoo Studio
www.tattoos.co.uk

(R) Paul Campion, Kinmel Bay, Wales.
Psycho Tattoo
www.psychotattoo.co.uk

PAGE 36
Steve Byrne, Leeds, UK.
In Name And Blood
www.myspace.com/inname andbloodtattoo

PAGE 37
(L) Dmitry Beliakov, St. Petersburg, Russia.
Tattoo Box
www.skinart.ru

(R) Gerardo Q. Garcia, San Antonio, Texas, U.S.A. Garcia Graphics
www.myspace.com/ garciagraphics

PAGE 38
(L) Mo Coppoletta, London, UK.
The Family Business
www.thefamilybusiness tattoo.com